Examples: The Making of 40 Photographs

ANSEL ADAMS

Examples: The Making of 40 Photographs

LITTLE, BROWN AND COMPANY

BULFINCH PRESS

BOSTON · TORONTO · LONDON

FOR WILLIAM TURNAGE

With Affection and Appreciation

First paperback edition, 1989
First hardcover edition, 1983

Library of Congress Cataloging in Publication Data

Adams, Ansel, 1902–1984
 Examples; the making of 40 photographs.
 1. Photography, Artistic. 2. Adams, Ansel,
1902–1984. I. Title.
TR642.A25 1983 770'.92'4 83-14903
ISBN 0-8212-1551-5 (hardcover)
ISBN 0-8212-1750-X (paperback)

Bulfinch press is an imprint and trademark of
Little, Brown and Company (Inc.)

Published simultaneously in Canada by Little,
Brown & Company (Canada) Limited

Printed in the United States of America

Contents

Introduction

After more than fifty years of serious photography I find my audience increasingly aware of my work and somewhat curious about facts and situations relating to my photographs. I am frequently asked, "How did you make this photograph?" The questions are often detailed, sometimes complex, and sometimes unanswerable. I have no secrets of craft; I answer as best I can inquiries on equipment, methods, and relevant situations. I have also used the detailed captions of my technical books as a means of teaching by example, and these have apparently been one of the books' most appealing aspects. I have often thought that a "problems and solutions" book that builds on the concept of the captions would be of value.

It is in response to public interest that I have written this book, in which I describe situations and methods relating to the making of some of my photographs. I have included reminiscences of the environments and the people involved, and have injected personal associations relating to the photographs and the subject whenever such seem appropriate. Recounting the events and situations leading to the making of a photograph and the mental and technical considerations involved in its production may have both educational and general interest values.

Absent from these pages are statements of what the photographs "mean." I cannot, and will not, attempt to describe, analyze, or define the creative-emotional motivations of my work, or the work of others. Description of the inspiration or the meaning of a work of photography, or of any other medium of art, lies in the work itself. The endless discussions of creativity appear to me to be pointless intellectual carousels; their purpose seems more the presenting of burnt offerings and worshiping of modish identifications than the achieving of mutual enlightenment. Only the print contains the artist's meaning and message. I hope that my creative and technical standards are supported in this book more through my images than through my dissertations.

Photography is in a period of development where means and methods sometimes hold unbalanced dominance over creative effort. As for myself, I have primarily reacted to photography at the aesthetic

and emotional levels. It is nonetheless true that description of the equipment and procedures employed is helpful to others in understanding one photographer's approach to his work.

In the process of reconstructing past events, certain limitations are unavoidable. While I have nearly always made accurate records of exposure and notes on the required processing, I seldom retained them after development of the negative. I can usually recall the visual aspects of subjects, and I sometimes remember details of the camera, lens, and filters used, and the exposure and development of the negative. But in many instances such details have not remained in memory, and I can make only tenuous suppositions. This is embarrassing, as I have strongly advised students and colleagues to make careful notes and *keep* them.

I have also been neglectful of noting the *dates* of my photographs and I have a notorious inability to remember them. I recall Beaumont Newhall, the great historian of photography, calling me one evening and almost with tears in his voice saying, "Ansel, your *Pine Cone and Eucalyptus Leaves* which appears in your last book is dated 1936. It is my painful duty to advise you that I have a magazine on my desk in which your picture is reproduced, published in 1934!" Edward Weston and Minor White kept meticulous diaries and records of their photographs; in many cases even the hour of day was noted, and precious comments were perpetuated. I was impressed with Minor White's consistent proofing of so many of his images; *good* contact proof prints were mounted on cards with accompanying title, date, and pertinent information. The serious scholar and historian deserves more than such simplistic dating as "early 1930s" or "c. 1956"! On the other hand, to me a date has little significance unless associated with some historic relationship that gives a time matrix for the making of the photograph.

My position in relation to contemporary photography is sometimes controversial, but I have always expressed concern for the future of the medium in its many directions. With what I believe to be a reasonable catholicism of approach, I have sincerely tried to grasp the content and purpose of contemporary work. I have been immensely pleased with many creative explorations I have seen; they are evidence of

great imagination and the awareness of enduring qualities of art. I often observe that the more "far-out" any work appears at first, the more exciting and valid it may prove to be.

I am not partial to the "in" syndromes or to any fundamentalist approach to the art creeds of past or present. I believe I can bring some excitement to the *craft* of photography; this is my obligation as teacher. I do not intend this knowledge to be used to encourage mere imitation of my work. It relates to the mechanics of the medium and may apply to all forms of expression in photography.

As with all creative work, the craft must be adequate for the demands of expression. I am disturbed when I find craft relegated to inferior consideration; I believe that euphoric involvement with subject or self is not sufficient to justify the making and display of photographic images. Taste and purpose are frequently distorted by social, political, and commercial motives, and the result often reveals weakness of originality and creative insight. We cannot be tolerant of any compromise of excellence.

We can do nothing about the past except make efforts to better understand and benefit from it, avoiding the pitfalls of sentimentality and nostalgia by which the old may sterilize the new. We can seek the most compelling evidences of creativity in the present and hope for an effective future — the potentials of which we can guess but never define.

Throughout this volume I have, to the best of my ability, striven for accuracy in the descriptions of equipment and procedures. The reproductions herein are rewardingly faithful to the qualities of the images. Within the text I have repeated, to a small extent, some basic technical information that relates directly to the image discussed. I have done this intentionally for easier understanding by the reader. However, I have not fully discussed the technical considerations in this volume; notes in each essay will lead the reader to the three books of the *The New Ansel Adams Photography Series (The Camera, The Negative,* and *The Print)* and *Polaroid Land Photography,* all New York Graphic Society Books, published by Little, Brown and Company, Boston. The notes refer to specific chapters and pages of these books, and I hope that helpful information will thus be

accessible. In addition, I have included brief explanations of some frequently used terms in the Glossary on page 173.

I wish to express my deep appreciation:

To Robert Baker, my very capable editor and associate in the production of *The New Ansel Adams Photography Series,* who has been most helpful in preparing this work —

To Mary Alinder, my Executive Assistant, for encouraging me to create this book and for offering her very sensitive and constructive comments on style and content —

To those who have kindly read and given valuable comment on my text, including my wife, Virginia; James Alinder, Executive Director of the Friends of Photography; John Sexton, my very able consultant; and my assistants, Chris Rainier and Phyllis Donohue —

To Robert Feldman of the Parasol Press, New York, for his kind permission to use Plate 7 from *Portfolio V;* Plates 1, 4, 6, and 8 from *Portfolio VI;* and Plates 2, 3, 6, and 10 from *Portfolio VII* —

And to my publishers for their most sympathetic attitude and cooperation. To all, I express my deepest thanks.

ANSEL ADAMS
Carmel, California
January, 1983

Examples: The Making of 40 Photographs

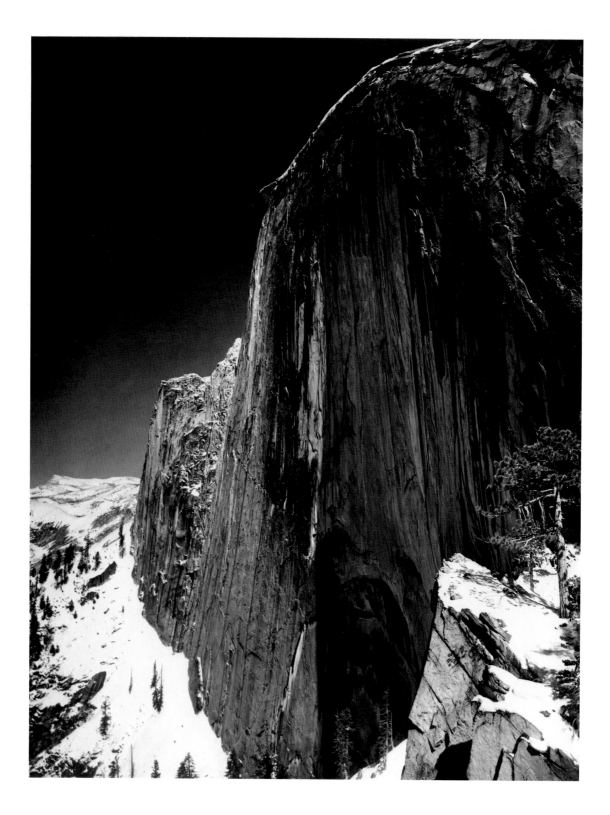

Monolith, The Face of Half Dome

Yosemite National Park, 1927

At dawn, on a chill April 17 in 1927, my fiancée, Virginia, two friends (Charlie Michael and Arnold Williams), and I drove from our home to Happy Isles and began an eventful day of climbing and photographing. I had my 6½×8½ Korona View camera, with two lenses, two filters, a rather heavy wooden tripod, and twelve Wratten Panchromatic glass plates. Those were the days when I could climb thousands of feet with a heavy pack and think nothing of it; I was twenty-five and weighed about 125 pounds. Virginia and friends were fine climbers in those pre-roping times, and nothing daunted us.

We started up Le Conte Gully, under the north cliff of Grizzly Peak. It is quite steep and rough, with some rock faces requiring caution, and ends about 2500 feet above the valley floor. It is not a gully in the ordinary eroded-earth sense of the term, but a sharply pitched rocky cleft that possibly began as a fault or a fracture plane when the granite batholith of the Sierra was elevated. It was *cold* in the gulley; patches of snow and ice remained in the recesses of the rocks, and a chilly wind flowed over us from the high regions above. It was an exhilarating and promising morning, and we were cheered to meet the sun after a hard, cold climb in the frigid shadows. Ahead of us rose the long, continuously rising slope of the west shoulder of Half Dome — nearly 1500 feet more to climb.

Midway to the dome I photographed Mount Clark with a Dallmeyer Adon telephoto lens. I used a Wratten No. 29 (red) filter and I did the arithmetic accurately, involving the effective aperture of the Adon (a variable magnification lens) and the filter factor.[1] The morning wind troubled the camera, and I waited for a lull that would permit a four-second exposure. I recall making three negatives of this; two were spoiled by the camera's movement during exposure.

I had made seven negatives all told by the time we reached the high area where the west shoulder meets the Dome, opposite the midway point of the 2000-foot cliff. This is called the "Diving Board," a tasteless name for such a wondrous place. It is a great shelf of granite, slightly overhanging, and nearly 4000 feet above its base. I made one photograph of Virginia standing on the brink of the rock edge, a tiny figure in a vast landscape. Score eight negatives. I tried a picture looking west into Yosemite

Valley; it was ruined because the plate holder was not properly seated. Score nine negatives. I made a picture of the North Dome complex, but I overexposed it (I think I forgot to stop down the lens!). Score ten negatives. I had two plates left — and the most exciting subject was awaiting me!

I turned to the face of Half Dome. When we arrived about noon, it was in full shadow. In early mid-afternoon, while the sun was creeping upon it, I set up and composed my image. I was using a slightly wide-angle Tessar-formula lens of about 8½-inch focal length. I did not have much space to move about in: an abyss was on my left, rocks and brush on my right. I made my first exposure with plate number eleven, using a Wratten No. 8 (K2) yellow filter, with an exposure factor of 2. As I replaced the slide I realized that the image would not carry the qualities I was aware of when I made the exposure. The majesty of the sculptural shape of the Dome in the solemn effect of half sunlight and half shadow would not, I thought, be properly conveyed using the K2 filter. I had only one plate left, and was aware of my poverty.

I saw the photograph as a brooding form, with deep shadows and a distant sharp white peak against a dark sky. The only way I could represent this adequately was to use my deep red Wratten No. 29 filter, hoping it would produce the effect I visualized. With the Wratten Panchromatic plate I was using, this filter reduced the exposure by a factor of 16. I attached the filter with great care, inserted the plate holder, set the shutter, and pulled the slide. I knew I had an exceptional possibility in my grasp. I checked everything again, then pressed the shutter release for the 5-second exposure at f/22. Because the lens barely covered the plate,[2] I was obliged to use a small lens stop, but fortunately there was no wind to disturb the camera during the long exposure. I most carefully inserted the slide and wrapped the plate holders in my focusing cloth for protection against the roughness of the long hike home. We left down the west shoulder of Half Dome into the Little Yosemite Valley and home via Nevada and Vernal Falls, arriving about dusk. I saw many gorgeous photographs on the way down but could do nothing about them, being out of plates.

This photograph represents my first conscious visualization; in my mind's eye I saw (with reasonable completeness) the final image as made with the red filter. I knew little of "controls." My exposures

were based on experience, and I followed the usual basic information on lenses, filter factors, and development times. The red filter did what I expected it to do. I was fortunate that I had that twelfth plate left!

Over the years I became increasingly aware of the importance of visualization. The ability to anticipate — to see in the mind's eye, so to speak — the final print while viewing the subject makes it possible to apply the numerous controls of the craft in precise ways that contribute to achieving the desired result.

I nearly lost this negative in my darkroom fire in 1937. On that occasion Edward and Charis Weston, Ron Partridge, and I had just returned from a trip in the Minaret country south of Yosemite. We had been packed in from Agnew Meadow and left for three days, and the packer and mules returned on the fourth day to pack us out. We made some fine images! We arrived in Yosemite in time for supper, but our evening of relaxation was disturbed by the fire. We were able to remove a good number of my negatives, but many early images were burned. We loaded the bathtub with wet negatives of all sizes, glass plates at the bottom, and spent several days cleaning and drying them. It was quite a traumatic event! I never learned the cause of the fire, but it may have started in an old dry-mount press (without thermostat).

This negative was slightly damaged on the top and left-hand edge, and it is necessary to trim off about $\frac{1}{4}$ inch from each. Happily the damage on the left is outside the trim area, but the loss at the top I could do without. Prints from before the fire show slightly more of the top edge of Half Dome. The negative is still printable, and I feel that my recent prints are far more revealing of mood and substance than are many of my earlier ones. The image is especially effective in a very large (40×50-inch) print.

I can still recall the excitement of seeing the visualization "come true" when I removed the plate from the fixing bath for examination. The desired values were all there in their beautiful negative interpretation. This was one of the most exciting moments of my photographic career.

1. Book 2, pp. 116–117.

2. Book 1, pp. 54–55.

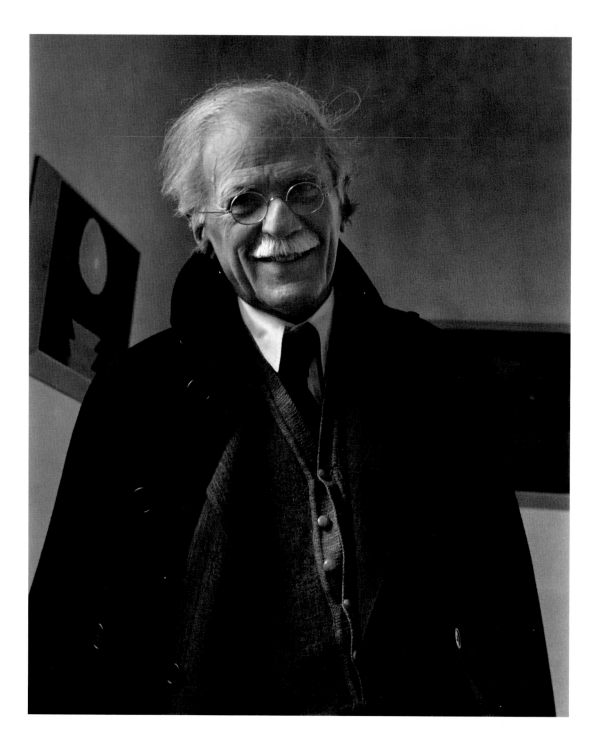

Alfred Stieglitz, An American Place

New York City, c. 1935

This is one of my first photographs with the Zeiss Contax 35mm camera, given to me by Dr. Karl Bauer, then the Carl Zeiss representative in America. Dr. Bauer was a very fine gentleman with a deep interest in photography and young photographers. I was proud to have a Contax; it was undoubtedly one of the finest cameras of the time. The Leica was also a superb instrument, of course, but I preferred the operational design of the Zeiss Contax. The original design of the instrument was refined on the basis of the practical experience of German photographers using pilot cameras. Because of this very sensible approach to design, the functions and operating controls were well planned, not only on the engineers' drawing boards, but from the photographer's viewpoint. I have worked with Contax I, II, III and the Contarex Professional (the last one produced). I still have the Contarex, and it works to perfection after more than thirty years' use.

On one of my various trips to New York in the 1930s, I visited Alfred Stieglitz with the Contax in hand and infected him with my enthusiasm for it. I was sitting on a stool in the main room of his gallery, An American Place, and had just finished loading a fresh roll of film when I saw him walking toward me. I quickly made an exposure. It happens to be one of the rare images of Stieglitz smiling. I was fortunate in guessing the exposure correctly. I do not recall the technical data except that it was made with the 50mm Zeiss Tessar lens. It is fairly easy to print on a normal-contrast grade of paper.

Stieglitz remarked, "If I had a camera like that I would close this place up and be out on the streets of the city!" Then he added, "I guess it is too late for me. I leave the job to you young people." He was aware of the image possibilities of the 35mm camera, but he knew little about its operation. Paul Strand had done beautiful "street work," but with a $3\frac{1}{4} \times 4\frac{1}{4}$ camera, usually on a tripod. He enlarged these negatives for many of his platinum prints and gravures that we see today. In the early decades of the century enlarging was not as widespread as it is now. The contact print was predominant, and small cameras were looked upon as toys. The larger size Kodak cameras were sometimes put to serious use; Arnold Genthe used a postcard-size Kodak for his remarkable photographs of San Francisco after the earthquake and fire

of 1906. With the advent of the 35mm and $2\frac{1}{4} \times 2\frac{1}{4}$-inch cameras the equipment and techniques of enlarging were refined, and today it is contact printing that is the exceptional process.

Stieglitz was distressed by the poor print quality so prevalent with small camera work. It was hard for either of us to understand the bleak quality of most of the 35mm work of the time. The reason was that there were then very few photographers using the small camera who had aesthetic/expressive intentions. For most, the 35mm camera was an instrument for the recording of scenes, events, and people, with the emphasis almost entirely on the realities and activities of the world. The camera was used primarily for reportage, and the prints made mostly for ordinary reproduction in magazines and newspapers, not for display.

Small cameras made such pictures far more immediate, and many negatives could be made in the time required to produce one with a sheet-film camera. The technique of 35mm photography appears simple, yet it becomes very difficult and exacting at the highest levels. One is beguiled by the quick finder-viewing and op-

eration, and by the very questionable inclination to make many pictures with the hope that some will be good. In a sequence of exposures, there is always one better than others, but that does not mean it is a fine photograph! The best 35mm photographers I have known work with great efficiency, making every exposure with perceptive care. It is also true that the small camera allows us to develop a composition of an active subject in time, and by recording a sequence of action we can modulate our perception to a final optimum image. The importance of the small camera in color work is obvious. The high quality of the lenses and the fine structure of the color emulsions have reduced the use of larger formats for color. There have been very substantial advances in the technical and aesthetic fields of photography within the past fifty years.

I always dream of going out into the world again with my Contax and my Hasselblad — on active duty, so to speak. Perhaps I shall do so after I have printed my many long-waiting negatives. In my professional years I made many negatives for myself as I worked, and these I developed, filed, and catalogued. But the pressure of

my assignments allowed me little time to print, and I am now faced with a substantial backlog! Stieglitz warned me of such possibilities; he said that when he divided his energies between development of An American Place and photography, he made fewer and fewer photographs. Edward Weston similarly admonished me about too many "involvements." But I have never appreciated an ivory tower attitude, and would prefer my work to evolve from, or at least co-exist with, the world of human interaction and activity.

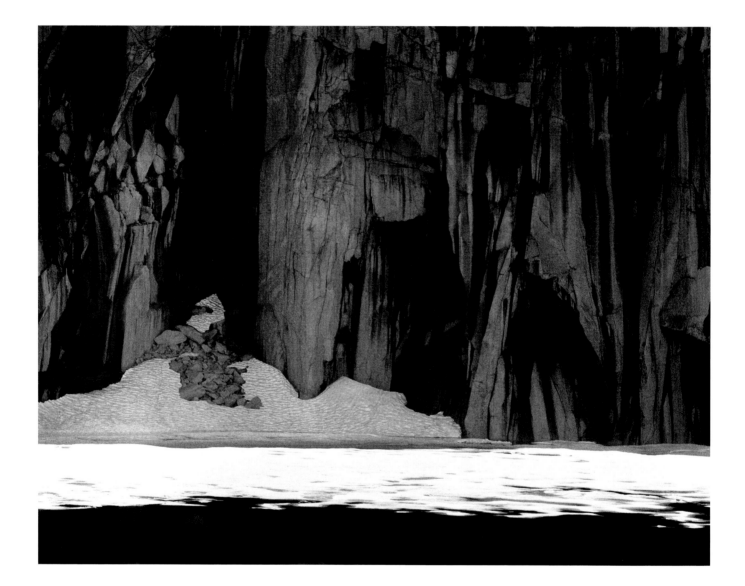

Frozen Lake and Cliffs

Sierra Nevada, Sequoia National Park, 1932

In my early days I frequently assisted in leading Sierra Club hikes in Yosemite and the High Sierra. I made this photograph while on the annual Club outing in the Kaweah and Kern River watersheds, in many ways the most spectacular region of the Sierra. On the long trek from Giant Forest over Kaweah Gap the trail passes Precipice Lake (not officially so named at the time), which lies at the base of Eagle Scout Peak. The lake was partially frozen and snowbanks rested in the recesses of the cliffs. I was impressed with the solemn beauty of the scene and saw the image quite clearly in my mind.

This photograph represents my transitional period into Group f/64 philosophy, which emphasized very sharp focus and full tonal scale, in reaction to the visual softness of the Pictorialism popular at the time. I was becoming confident of my seeing and had considerably developed my craft, although the Zone System was about eight years in the future, spot meters were unheard of, and even film speeds were approximate at best. There is no doubt that the aesthetic influences of the time were unfolding in my work, as in the work of other photographers. I had yet to meet Stieglitz and experience my introduction to a far greater world of art and photography. But I had been building my personal aesthetic since meeting Paul Strand in New Mexico in 1930, a very important event for me.

Many speak of this image as abstract, but I was not conscious of any such definition at the time. I prefer the term *extract* over *abstract*, since I cannot change the optical realities, but only manage them in relation to themselves and the format. For photographic compositions I think in terms of creating configurations out of chaos, rather than following any conventional rules of composition. Edward Weston said simply that "composition is the strongest way of seeing." At any event, I believe I was able to express in this photograph the monumental qualities of the subject that I responded to so intensely at first sight. In those days I could imagine the composition and the desired values fairly well, but I did not then have the necessary craft to relate exposure and development precisely for optimum results.

I was using a 4×5 Korona View camera

and one component of a 10-inch (25cm) Goerz Double Anastigmat lens of brass-barrel antiquity. The single component, rear in this case, with a focal length of about 19 inches, gave a considerably larger image than the combined lens. A normal lens for the 4×5 camera (roughly 6½-inch focal length)[1] would have included a much larger field of view than I wanted. The 19-inch lens component gave me precisely the composition I visualized.

It was a complicated exposure problem: the deeply shadowed recesses of the cliffs contrasted with the blinding sunlit snow, taxing my intuition and the range of the film as well. I was fortunate with my exposure: I had no way to measure the specific luminances of the distant subject with my early Weston meter, so I gave one lens stop more exposure than average and hoped for the best. I remembered to adjust the aperture for the single component and check the focus shift[2] of the 19-inch single component — easy to forget when one is in a hurry! I had no firm concept of the Zone System at that time; a few years later I could have better controlled the glaring ice on the lake and also strengthened the shadow areas by water-bath development of the negative.[3]

And, unfortunately, when I developed the film a month later, I apparently used fatigued (a nicer term than "exhausted"!) developer. The negative is somewhat degraded, especially in the areas of the shadowed cliffs, and it is *very* difficult to print. Only within the past year or so have I been able to get a nearly satisfactory print, using Oriental Seagull Grade 4 paper. The ice is blocked up in the negative to a degree requiring a very long burning-in time, which I gave at first using a long, narrow cut-out area in the burning card.[4] However, it is hard to avoid darkening the adjoining areas. I found that a better method was to divide the basic exposure into two parts, first burning-in the foreground reflection area starting from the *top* of the ice, then burning the cliffs starting from the *bottom* of the ice. It is important to keep the broad edge-shadow (penumbra)[5] of the card in constant motion. Thus the ice receives about twice the exposure given the cliffs and the reflection area.

Making the print involves the use of many controls and trials to obtain results that approximate what I saw and felt when I made the exposure. I am fortunate to have had so many good results in the years of my technical insufficiencies! The photogra-

pher can work on an empirical basis and establish certain procedures for consistent situations, and, with experience, he can knowingly deviate from the norm for expressive purposes. However, confronted with new conditions of light and subject scale, he will require empirical refreshment. With the advent of the Zone System, the guesswork was removed from unfamiliar situations, and good control of results became possible.

I am interested in why I see certain events in the world about me that others do not see, while they respond to different events. On the day that this photograph was made there were several other photographers nearby, some very good ones who were then far more technically advanced than I. The scene was before us all, but no one else responded with creative interest. Cedric Wright, close friend, violinist, and photographer from Berkeley, observed what I was doing and, half in jest, set his camera up in my location. I saw his print later; he did not have a lens of appropriate focal length and he overexposed his negative. On seeing my print he exclaimed, "Jeez! Why didn't I see *that!*" I have seen some of his prints that have evoked the same comment from myself. He made many beautiful photographs of the Sierra and was an excellent portraitist. He also had a rare sense of photographic humor.

With all art expression, when something is seen, it is a vivid experience, sudden, compelling, and inevitable. The visualization is complete, a seemingly instant review of all the mental and imaginative resources called forth by some miracle of the mind-computer that we do not comprehend. For me this resource is not of things consciously seen or transcriptions of musical recollections; it is, perhaps, a summation of total experience and instinct. Nothing modifies or replaces it.

1. Book 1, pp. 55–57.

2. Book 1, pp. 52–53.

3. Book 2, pp. 229–232.

4. Book 3, pp. 102–110.

5. Book 3, pp. 105–107.

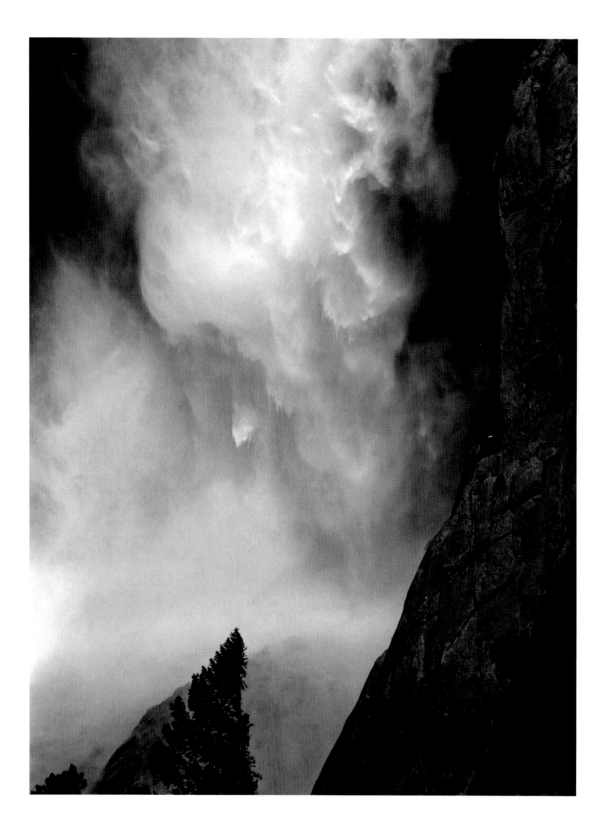

Base of Upper Yosemite Fall
Yosemite National Park, c. 1950

As a youth I scrambled all over Yosemite, my mind filled with the aura of music and my body taking risks unrealized at the time. There were no climbing techniques as we know them today. I scrambled about alone or tied to a companion with a thin rope or window-sash cord, which could have meant that if one of us fell the other would probably follow. I usually took a small camera with me but made few pictures of any merit other than as recordings of exciting situations in very unexciting style. Most of these early negatives from the 1920s were consumed in my darkroom fire in Yosemite in 1937. They were filed in batches in envelopes that were stored in a cardboard box, apparently near the source of the fire. Since they were mostly nitrate-base film they must have burned fiercely; it was fortunate that they were stored at some distance from most of my other negatives. As it was, I lost many photographs. I cringe with shame over my carelessness.

In the early 1930s my excursions were more cautious, and I used my camera with serious intent. My cameras of that period were 4×5 Korona View, 5×7 and 3¼×4¼ Zeiss Juwels, 5×7 Linhof, 5×7 Deardorff, 4×5 speed Graphic, 2¼×2¼ Zeiss Super-Ikonta B and a 35mm Contax — not all possessed at one time! My wife, Virginia, properly appropriated the Super-Ikonta B, and it remains a fine operational camera to this day. I used mostly the Zeiss Juwels, especially the 5×7 model, adapted to old-style Graflex backs. I used Graflex 3¼×4¼ and 4×5 roll-film holders, and Graflex magazines, sheet-film holders and film-pack adapters. I later had the Juwels and other cameras adapted for standard Graflok backs. Add to the list my 8×10 view camera for studio work and automobile, pack-mule, and short backpack excursions.

In earlier days I could climb thousands of feet, on or off trails, carrying a backpack load of fifty or sixty pounds, with the ease and abandon of a mountain goat. I now realize how wonderful those days were and what reserves of strength and endurance we had when only twenty and thirty years old! I wish I had kept up my full physical activities when I was forty and older, but I became more sedate as the years passed, spending more time in the darkroom and at the typewriter.

One spring morning in 1950, Yosemite Fall was booming in flood, and I climbed to the base of the upper fall via Sunnyside

Ledge and the granite slopes east of Yosemite Creek. I was carrying the $3\frac{1}{4} \times 4\frac{1}{4}$ Juwel with two Graflex magazines, each holding twelve sheets of Agfa Super-Pan Supreme film. It was a grand and relatively safe scramble. I could have moved closer to the fall except for the gusts of driving spray that would have soaked my equipment.

I used my 7-inch Zeiss-Dagor or my newly acquired Kodak 8-inch Anastigmat (later known as the Kodak Ektar). I was primarily interested in details of the falling water. I can clearly recall the continuous shattering sound of the waterfall and the constantly changing combinations of amorphous water masses punctuated with the meteor-like white arrows that held their shape from their thrusting formation at the top of the fall. At times the swirling mist would veil the more solid shapes of the falling water, then clear to reveal them in great depth.

I managed a composition of a lower section of the fall with small wind-blown conifers in the lower left corner. The branches of the right-hand side of the trees (facing the fall) are stripped — either by the driving force of water and wind or by winter ice falling from the cliffs above. I was aware of them as exciting accents to the more flowing shapes of the waterfall and to the strong vertical cliffs on the right. The sunlight was slightly hazed. I used a yellow Wratten No. 8 (K2) filter to lower the bluish shadow values within the water. When I had the basic composition determined, I waited for a considerable time for optimum conditions. There was a constant change of fast-moving shapes in the water, and gusts of windy spray would frequently force me to keep the camera covered with my focusing cloth. When the spray disappeared I would uncover the camera and await the precious moment. I made at least eight negatives before I felt I had succeeded, and then I made a few more to be sure. Clouds soon covered the sun, and with great expectations I returned to our home to develop the negatives. One was superior to the others, and I retained it along with a close variation. It was first reproduced in the Sierra Club publication *The Eloquent Light*, text by Nancy Newhall (1960).

The longer I worked in Yosemite and the Sierra Nevada, the more convinced I became that the inclusive landscapes — strik-

ing as many undoubtedly are — may not interpret the direct excitement and beauty of the mountain world as incisively as sections, fragments, and close details, which are available in infinite number if the photographer will carefully observe. The danger, of course, lies in becoming repetitive; the photographer must be highly selective. Awareness of shape evokes form, and the renditions must be distinguished by fine craft. The natural details by Edward Weston; the strong natural and mechanical subjects revealed impressively by Brett Weston; the brooding, quasi-mystical impressions of Minor White and Wynn Bullock; and many of Eliot Porter's subtle details of stone and forest clearly suggest that landscape photography can be an intimate art form not necessarily dominated by the grand, remote aspects of the world or the passing excitements of events.

One subject, such as the image discussed here, has unlimited potentials for expressive variations. Repeated returns may be more rewarding than prolonged waiting for something to happen at a given spot. With this subject something was always happening, but I was obliged to await particular moments when the mind could anticipate the subject-event that would intuitively create, for me, an effective image.

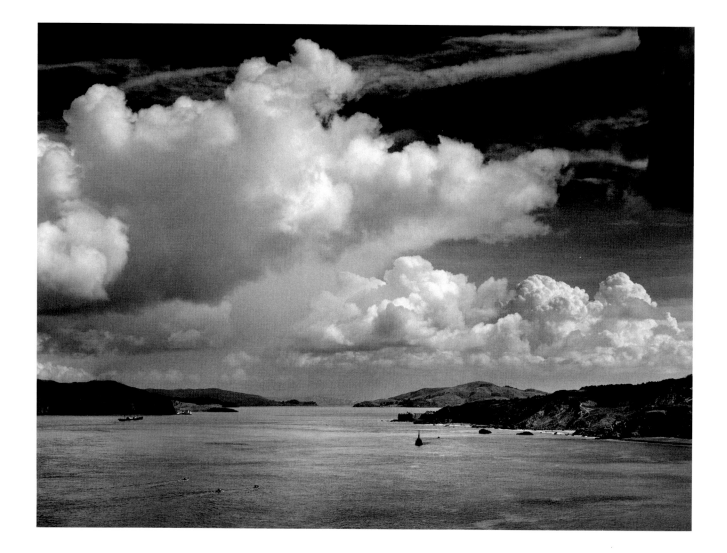

The Golden Gate before the Bridge

San Francisco, California, 1932

One beautiful storm-clearing morning I looked out the window of our San Francisco home and saw magnificent clouds rolling from the north over the Golden Gate. I grabbed the 8×10 equipment and drove to the end of 32nd Avenue, at the edge of Seacliff. I dashed along the old Cliff House railroad bed for a short distance, then down to the crest of a promontory. From there a grand view of the Golden Gate commanded me to set up the heavy tripod, attach the camera and lens, and focus on the wonderful evolving landscape of clouds.

The clouds were moving fast. I recall that before I could get the camera set up a handsome composition disappeared in the swirling mists that veiled not only the distant hills but the crisp edges of the clouds. I feared I might have lost a fine image, and I waited impatiently as the white masses formed and re-formed without resolving into an effective composition. By remembered comparisons I knew how filters changed atmospheric effects and values; it seemed right to use the strong yellow Wratten K3 (No. 9) filter here to reduce the atmospheric haze. My filters were 3-inch-square Type B glass (a square of the filter

gel mounted between two thin sheets of glass). I always focused with the filter in place, especially if it was set behind the lens; otherwise inaccurate focusing would result.

When the clouds finally came together in glorious array, the steady wind vibrated the camera. I waited as long as I could; then, tightly holding the focusing cloth around the camera, I made the exposure. I recall that I used $1/25$ second at f/16 with the K3 filter. The negative is quite sharp; I have enlarged it to 30×40 inches, and it holds good definition in spite of visible grain in the middle-value areas.

I had recently acquired my first 8×10-inch view camera, which replaced my $6\frac{1}{2}×8\frac{1}{2}$-inch Korona View. This handsome smaller format is now of the past, although, as a logical size between 4×5 and 8×10 formats, it had a particular aesthetic appeal. But 8×10 was "in" and I could not exist without one (so I thought), especially for professional work. It was always ready, with film holders loaded.

I had bubble levels on both front and back components of the camera and could be reasonably certain of adequate alignment. The monorail cameras of the present

are far more precise and sturdy than the wooden assemblies of my youth. Unless properly supported, the elderly bellows would sag and vignette the image. The bellows would also develop pinholes; with old cameras constant checking was important (and it is not to be overlooked today). After a considerable number of black patches were plastered on the leather folds it was deemed necessary to buy a new bellows, which was sometimes quite costly. The groundglass panel might develop weakened springs, and it was very important that the film holders were securely seated. In time the raised wooden light-trap flanges of the holders would become worn and light-streaks would result. For all these reasons we always kept the focusing cloth over the camera while exposing.

My outfit included a 12¼-inch Turner-Reich Triple Convertible lens in a shutter that worked best at Bulb and 1/25 second; Wratten K2, K3, A, and F filters (now Nos. 8, 9, 25, and 29); six double film holders; focusing cloth; and a sturdy wooden tripod with tilting head of archaic design. A nondescript case completed the list. I do not think I had an exposure meter at the time, but instead depended upon experience,

which sometimes treated me well. I confess that in those days I did much bracketing of exposures (making negatives with more and less than the exposure believed to be correct, for security). This was expensive, but psychologically rewarding at the time. For most work I was using Kodak Super-Panchromatic film and a pyro or pyro-metol developer. I would grasp at any formula I heard about; in fact, I made some beautiful negatives with amidol (which is generally used for print developing). Most of us made contact prints and were not worried about grain on the 8×10 negatives.

I do not recall where and how I obtained the 8×10 view camera, but I think I purchased the lens from Frank Dittman, who hired me as darkroom assistant in his photo-finishing business in San Francisco around 1918–1919. I recall paying him ten dollars for the Turner-Reich lens, and I put out five dollars for shutter repair. The lens served me well until after I had made the Golden Gate picture. Since I sold quite a few prints of this subject, I was able to turn the lens in for a Goerz Dagor in a superior Compound shutter, which in time gave way to a Cooke Triple-Convertible Series XV lens of 12¼-inch focal length.

The characteristics of lenses made before the 1930s had much to do with image quality. In those days lens coating was unheard of. We knew from experience that some lenses were more "brilliant" than others, and we empirically adjusted development times to compensate. The uncoated filters added to the light scatter, and internal reflections from poorly designed and less-than-black bellows interior further reduced image contrast. When we see photographs made before the 1930s, we can assume they were made with uncoated lenses. We also note that in many instances the shadows have more substance than seen in present-day images.

In those days I used normal development — a certain time at a given temperature — and hoped for the best. Occasionally, when I knew the image might be a bit flat, I gave more development time, and when I had a subject of high contrast I gave less time.[1] As exposure was based on some "normal average," I trusted the latitude of the negative material and the flexibility of the printing procedures. I had no concept of the subtle Zone System controls, but I made many photographs that have held up well over the years, and this is one of them.

This photograph of the Golden Gate has always been popular. One photographer loudly protested that my picture was not the *real* Golden Gate; it was "too pretty" and "decorative." For me, it remains a very positive experience and a memory of an impressive day.

1. Book 2, pp. 71–79.

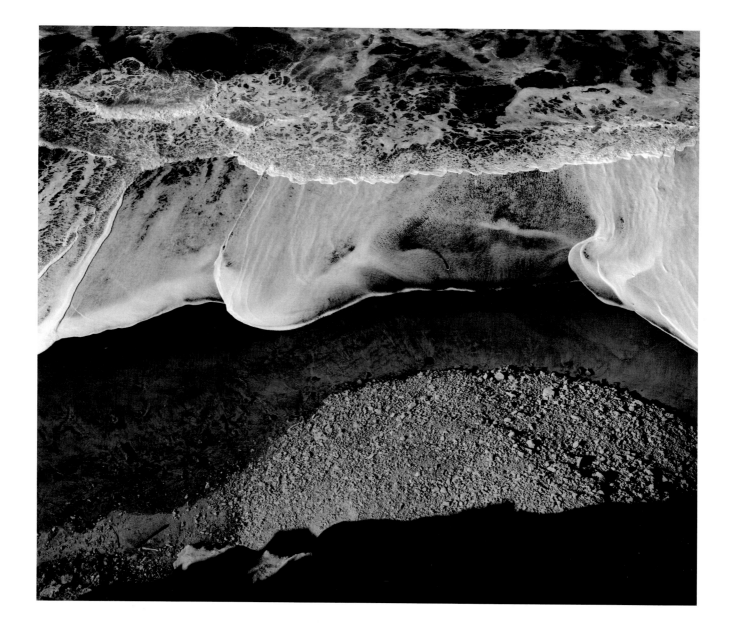

Surf Sequence

San Mateo County Coast, California, c. 1940

Very early one morning I was driving to Carmel along Highway One south of San Francisco, and I frequently stopped the car to walk out to the brink of the cliffs overlooking a lively surf. At one location I noted that below me was a nice curve of rockfall fronting the beach. The surf was streaming over the beach, barely touching the rocks and creating one beautiful pattern after another. I realized that I could perhaps make a series of images that might become a sequence, so I set up the 4×5 view camera and awaited appealing arrangements of flowing water and foam.

It was a crisp shining day with an approaching band of fog over the sea, and I was a bit concerned that the seasonal gray mantle would soon come over the coast. I used a rather long focus lens, a 10-inch (250mm) Dagor, which gave a good field of view from my high vantage point, and I was able to anticipate roughly where the surf would enter the field of view at the top of the picture area.

I took average readings with the Weston meter, which, because of more or less white water showing in the field, varied between 150 and 250 candles per square foot[1] (c/ft^2). I used 200 c/ft^2 as the basic lumi-nance value for all the exposures. As I recall, the exposures were about $1/100$ second at f/11. All negatives were developed together for normal time in a tank with Kodak D-23 developer. I used medium speed film at ASA 64.

In subjects of this type there are many flowing, interweaving lines and surges of white and gray; the photographer must be alert to the combinations confronting him, and must try to anticipate the position of these moving shapes in time. I failed in this precise judgment with several of the exposures; I made about nine negatives in all, but I discarded some because of the disposition of the surf in the picture area. I ended with five satisfactory compositions.

As I photographed, I became aware of the relation of one image to those preceding and following, and I could imagine what the sequential patterns might be in the final set of prints. It is possible to determine the actual sequence of the exposures by observing the movement of the shadows on the rocks, caused by the rising sun behind me. However, the chronological sequence is not especially important, and the prints can be displayed in any order desired.

Printing the sequence was not as simple

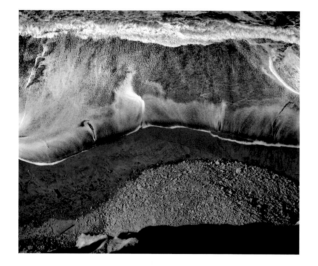 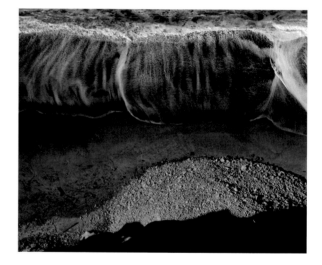

as I expected. The white sunlit foam value fell rather high on the exposure scale and the D-23 developer encouraged a little blocking of these high values.[2] The paper I used at first was Agfa Brovira Grade 3. The most recent printing was on Ilford Gallerie Grade 2, with quite full development in Dektol. I tried Grade 3 Gallerie with Kodak Selectol-Soft developer, but I could not hold the texture I wanted in the highest values. All prints were toned in selenium.[3]

There was, of course, need for tonal balance if the prints were to be shown as a se-quence. I thought that once I had a fine print from one of the negatives it would be a matter of simple repetition for the four others. I was mistaken, for two reasons: One, during the twenty minutes required for all the exposures, the sun continued to rise and the general luminance value in-creased; each negative was a bit more ex-posed than the preceding one, resulting in a little more density as the series progressed. Two, as foam and water receded from the beach, the revealed sand would change value, gradually growing lighter as the sand

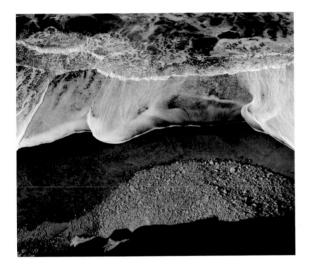

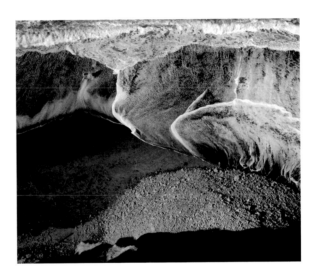

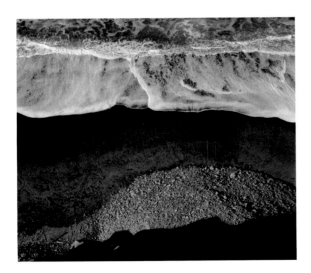

absorbed the water. After the next wave it would return to its darker value. These variations in the negatives required rather intricate dodging and burning[4] to maintain an acceptable degree of value balance in the sequence.

The final trim of the print margins presented a new problem. Since I wanted all five prints to be precisely the same size, as befits a sequence of this character, I had to work from the one that needed the most cropping on the right margin (the other three margins were but slightly changed). All the other images would tolerate the same right-margin trim. This was necessary because of the configuration of the sand and stone: the right-hand surge of surf was channeled into a vertical shape in three of the negatives, and this was a very distracting detail. Removing it from these three images demanded that the other two images be likewise balanced.

My attention to such small details — being certain that each print is of the same cropping and values — is a matter of personal taste and desire for perfection. There is something architectural in precise image construction. If I had been using a reflex camera (which shows exactly what the lens is seeing), I would have been more aware of the margins. For example, with reflex cameras like my old Graflex or my Hasselblad, I would have had a precise idea of what the waves were doing throughout the images. With a view camera, such changing edge situations can be only estimated.

Were I making this sequence today I would undoubtedly use the Hasselblad with the prism finder and, probably, the 120mm or the 150mm lens. Although some might expect me to, I would not necessarily select a fine-grain film. Moving foam is usually rendered somewhat unsharp; the minute bubbles blend and blur and the image is not crisp. If the negative grain appears sharp, the bubbles may seem less blurred. I would use a medium speed, medium grain film (perhaps Plus-X rather than Pantomic-X) with a very fast shutter speed to arrest motion, and would develop Normal-plus-one[5] in a fairly concentrated developer solution. If light grain appeared, it would enhance the illusion of sharpness of the foam, and would be absorbed in the texture of the sand. Gross grain could not be tolerated.

This sequence is a progressive series of images of the same general subject. Minor

White produced many-subject sequences that held together mostly because of their related subjective content. It is possible to select sequences and passages from a number of photographs, and these groupings often function in exhibits and portfolios far better than random choices. As Minor said to me, "A sequence of several images can be thought of as a single statement."

1. Book 2, p. 12.

2. Book 2, p. 87.

3. Book 3, pp. 130–134.

4. Book 3, pp. 102–110.

5. Book 2, pp. 71–79.

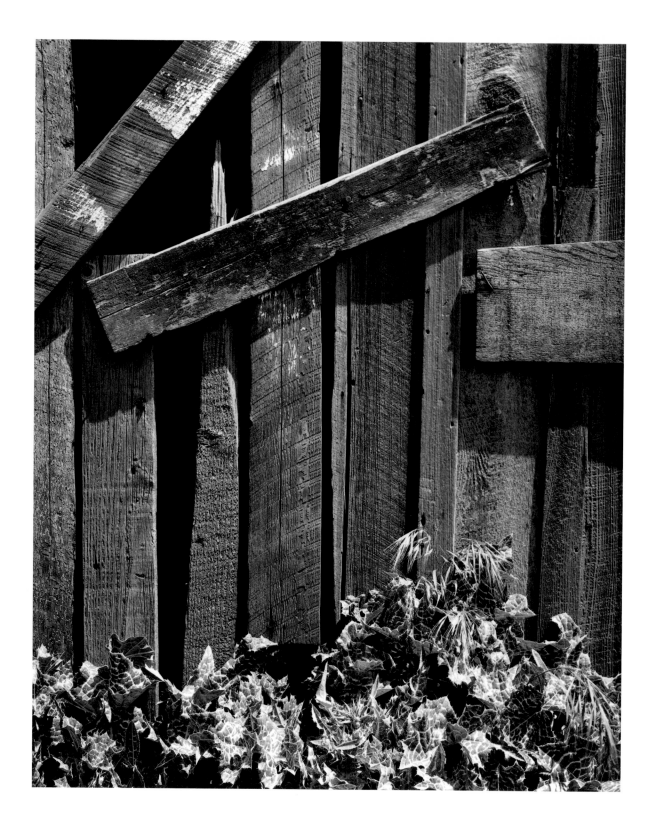

Boards and Thistles

San Francisco, California, c. 1932

In the early '30s the Salon syndrome was in full flower and the Pictorialists were riding high. For anyone trained in music or the visual arts, the shallow sentimentalism of the "fuzzy-wuzzies" (as Edward Weston called them) was anathema, especially when they boasted of their importance in "Art." After about two years of growing concern over the position of creative photography, a number of us photographers (mostly in the San Francisco area) formed Group f/64 in 1932. In many ways Willard Van Dyke and I were the prime movers in its formation, and we had the warm support of Imogen Cunningham, Edward Weston, and other serious creative photographers of the West Coast. We felt the need for a stern manifesto!

There were a few sincere and creative workers among the Pictorialists whose concepts were superior even if their craft was not always adequate, and these were not included in our general excommunication. Will Dassonville produced beautiful photographs (as well as an excellent photographic paper, Dassonville Charcoal Black). William Mortensen had an advanced grasp of practical sensitometry and produced a very informative book, *The Negative.*

However, the incredibly bad taste of his photographs smothered, for us, the validity of his contributions to the craft. In 1932 the two aesthetic extremes of West Coast photography were Weston and Mortensen.

Elated with the fervor of Group f/64, we all strove mightily to prove the point, so to speak, of the emerging concept. We did not fully realize at the time that Alfred Stieglitz had devoted himself to similar goals since the turn of the century, though his style was different, savoring of the textured papers and softer delineation of the early 1900s. What we lacked in historical knowledge we made up for by our enthusiasm. We sought purity of the image — sharp optical qualities, in-depth focus, and smooth papers. We were defining (we believed) a fresh aesthetic. In the main this was true, although definitions of "pure" or "straight" photography usually include the images of Stieglitz, Strand, and others whose work reflected the concepts of the visual arts of the time in terms of subject selection and composition. In time we softened the hard edges of our opinions.

With youthful excitement I attacked photography with a sharp lens, 8×10-inch camera, and aggressive confidence. My

most gratifying image was one of the first of this period; *Boards and Thistles* demonstrated the application of purist principles. It is extremely sharp, since I used my 300mm Goerz Dagor at f/45 and developed the negative in pyro,[1] and it was printed on glossy paper.

Making the photograph was an experience I can recall vividly. It occurred about 11 A.M. on a clear, crisp San Francisco day. I was walking along a street in the southern section of the city, carrying my 8×10 camera-on-tripod over my left shoulder and a case with the film holders in my right hand, looking for that moment of true excitement experienced not too often by serious photographers. I came across this striking arrangement of weathered boards, the side of an old barn. Bright thistles glistened, and the gray boards were sunlit at an angle that enhanced their textures.

I measured the average luminance with my Weston meter; in retrospect I am certain my exposure was equivalent to placing this average value on Zone V½, and the shadow detail fell on or below the threshold of the exposure scale of the negative. Since there was a slight breeze, enough to stir the thistles, I had to wait a little time for the quietness required for a half-second exposure.

Pyro (as I used it then) gave a strong image. In modern terms I would say that the negative was a little underexposed and given slightly more than normal development. Contrast is further enhanced now by printing with Oriental Seagull Grade 3 paper. It is one of those unusual images that works well at any size. I first contact-printed the image, then made enlargements up to 40×60 inches. As I recall, my first print from this negative was on Novobrom, a Gevaert product; later on I used duPont papers, and then Agfa and Kodak papers. All were enlarging papers. Edward Weston preferred contact materials,[2] such as the fine Convira and Haloid papers of the time. To the best of my knowledge he did not enlarge his negatives after he left Glendale for Mexico in 1923.

Looking back fifty years I am both pleased and perplexed at some of the work accomplished in those days of dedication and brashness. The composition of *Boards and Thistles* is quite sophisticated. While I avoid directly relating visual experiences to music, I feel that in this case the organization and texture of the image might have

some intangible relationship to musical structure and values. I did another picture of a barn side in the same area; it has a quite different quality and mood. The use of the word "mood" is questionable in relation to images, but I know of no other word to match it; perhaps mood is a quality of both subject and interpretation. I can say that this photograph reveals quite convincingly what I saw and felt at the moment of exposure.

1. Book 2, p. 233.

2. Book 3, pp. 46–48.

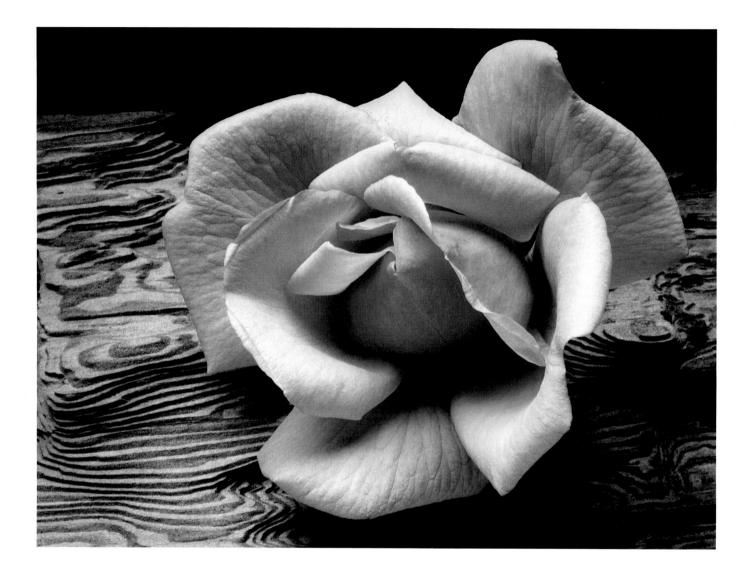

Rose and Driftwood

San Francisco, California, c. 1932

I had a fine north-light window in my San Francisco home which gave beautiful illumination, especially on foggy days. My mother had proudly brought me a large pale pink rose from our garden, and I immediately wanted to photograph it. The north light from the window was marvelous for the translucent petals of the rose, but I could not find an appropriate background. Everything I tried — bowls, pillows, stacked books, and so on — was unsatisfactory. I finally remembered a piece of weathered plywood, picked up at nearby Baker Beach as wave-worn driftwood. Two pillows on a table supported the wood at the right height under the window, and the rose rested comfortably upon it. The relationship of the plywood design to the petal shapes was fortunate, and I lost no time completing the picture.

I used my 4×5-inch view camera and an 8-inch Zeiss Kodak Anastigmat lens (one of my first lenses) and Kodak film of, I recall, a speed of ASA 50. I confess I "bracketed," making six exposures at different settings; one was successful! I was working fairly close to the flower and had a serious depth-of-field problem.[1] I used the smallest stop of the lens, f/45, and gave about five seconds exposure for the best negative. This was made before I had learned of the reciprocity effect.[2]

The original concept of the image was rather soft, but the shadows in the negative turned out quite thin. I could visualize an image to a degree, but at the time I did not understand the essential exposure and development controls. As I occasionally printed this negative over the years I worked for greater richness of values. The first print was on Gevaert Novobrom paper; recent prints are on Oriental Seagull Grade 2, toned in selenium.

I have been asked what influenced me to make this picture. At that time, it was widely believed that every photograph should relate to some example in another art form. I seldom, if ever, thought that a photograph might be influenced by another photograph. Of course I had seen flower paintings, but never, as I recall, one of a single large flower. I certainly had not seen any of Georgia O'Keeffe's marvelous large paintings of flower forms. In retrospect I believe that this picture was an isolated inspiration, free of any association in art that I

knew about. It was simply a beautiful object with a sympathetic background and agreeable light.

This was certainly an arranged subject. I did not question the arrangement or contrivance, although it was not what I would recognize later as a "found object."

There is a profound difference between the found object and a contrived subject. The found object is something that exists and is discovered. In the chaotic world about us we perceive some object or group of objects that stir the imagination. For me it is most often an immediate reaction; the more I *look* for something, the less chance there is for finding anything of value.

Contrived subjects are selectively organized, whereas the found object is subject to analytic consideration. The visualized image is, of course, a swift decision, but it is necessary to think of viewpoint, focal length of lens, the exposure-development program, and so on, to achieve the desired results.

A contrived subject does not suggest anything questionable; most studio work of all types involves carefully planned and arranged photographs, and some are very beautiful. In studio photography I think of the subject as being planned and constructed somewhat as a stage set would be; shapes, values and contrasts, lighting, and backgrounds are composed *outside* the camera. The camera and the process are then used to record the subject that has been created. Working with the found object is a quite different intellectual and emotional experience. Edward Weston, with great sensitivity and devotion, arranged his shells and peppers as dynamic compositions, and no one questions their beauty. He was definitely working on "assignments from within," and the results were equal in intensity to those images he made of large vistas, intimate natural fragments, and the relics of society when working in the field.

We observe few objects really closely. As we walk on the earth, we observe the external events at two or three arms' lengths. If we ride a horse or drive in an automobile, we are further separated from the immediate surround. We see and photograph "scenery"; our vast world is inadequately described as the "landscape." The most intimate object perceived daily is usually the

the printed page. The small and common-place are rarely explored.

With a few scientific and creative exceptions, the near objects of the world about us have rarely been considered by the camera. Blossfeld, in *Art Forms of Nature,* revealed a fresh experience of vision. Atget, Renger-Patzsch, Cunningham, Worth, Strand and Edward and Brett Weston have looked closely at the world; their cameras have moved in upon a hitherto unrespected universe. The micro-world (the world beyond human vision) is extraordinary, but the macro-world (encompassed by the close-exploring eye) seems most favorable to the lens and to creative expression.

Most of my photographs made before 1930 were of distant grandeurs. But as I learned the inherent properties of camera, lens, filters and exposure, I also gained the freedom to see with more sensitive eyes the full landscape of our environment, a landscape that included scissors and thread, grains of sand, leaf details, the human face and a single rose.

My meeting with Paul Strand and the development of Group f/64 made me conscious of the elements of art in selection, seeing, and executing. I often wonder what my work would have been had I not met Strand and Stieglitz and encountered the Group f/64 experience. It was the Strand–Group f/64 influence that determined my decision to turn from music to photography, and I might otherwise have continued as a musician. We can never know where the momentous alternatives in our lives might have led us.

1. Book 1, pp. 48–52.

2. Book 2, pp. 41–42.

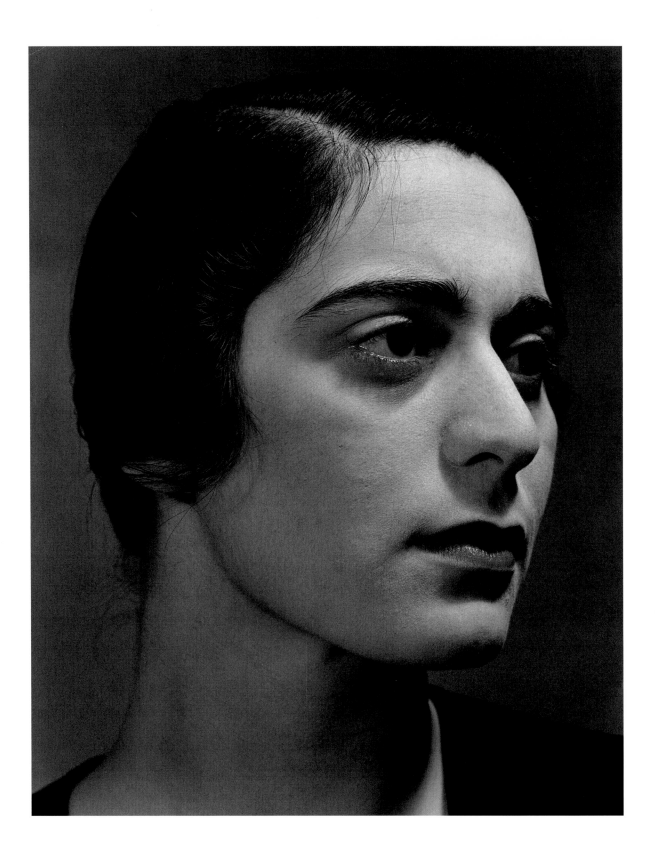

Carolyn Anspacher

San Francisco, California, c. 1932

One evening in San Francisco in 1928, Albert Bender (my first and most significant patron) took Virginia and me to a performance of *The Dybbuk*, a remarkable Jewish play by Solomon An-Ski, directed by Nahum Zemach. The star, tall, strikingly handsome, and immensely gifted, was a young protégée of Albert's. From that evening Carolyn Anspacher was our life-long friend. For some unexplained reason, Carolyn later left the stage and entered newspaper work, joining the staff of the *San Francisco Chronicle* and remaining there as a reporter-writer until her death in 1980.

I made this photograph of her with a 4×5 Korona View camera, a 12-inch Voigtländer process lens, and the recently introduced foil flash lamps (the No. 75's, which have long since disappeared). These were installed in brushed aluminum reflectors, each of which was equipped with a tungsten modeling light; carefully positioned at appropriate distances from the subject, the two units gave beautiful light.

I was impressed with the results, but many were not. It was called "The Great Stone Face" and was thought by some to be a picture of a sculptured head. This actually pleased me, because at the time I had a strong conviction that the most effective photographic portrait is one that reveals the basic character of the subject in a state of repose, when the configurations of the face suggest identity and personality. This is often accomplished by using an exposure of one or more seconds. With flash, it is a matter of anticipating the desired expression, rather than leading the subject into a prolonged posed situation.

I am still of this persuasion; the usual "candid" photograph is but one moment of the subject's lifetime, a fragment usually related only to the artifact of the shutter's action. A painter can synthesize many impressions, observations, and reactions — creating a single expressive complex. The portrait photographer has only one passage of time (long or short) in which the delineation of the face is defined. Occasionally an image of a passing expression can represent a broad aspect of the personality, but it is rarely a complete portrait.

Photography at the time of Hill and Adamson (1840s) demanded very long exposures, as the negative material was extremely slow. Alfred Stieglitz, using the

faster materials of the early 1900s, continued the static concept. He would make his subjects sit for two minutes in a fixed (and, it was hoped, relaxed) position. I considered this approach dependent upon a form of hypnotism, but Stieglitz maintained that the beauty of the nineteenth-century portraits made on the very slow materials of the time depended upon the static situations that long exposures demand.

Photographic reportage in our time depends largely upon the moment, often captured by electronic flash or very fast shutter speeds. Images of high aesthetic value can be made by this means. My picture of Georgia O'Keeffe and Orville Cox (page 152) is not, in my opinion, a *portrait* but a rewarding record of a valued moment and engaging personalities. Combine the optimum moment with the ambience of a fine print, and perhaps a successful photograph is achieved.

The element of anticipation is, of course, a most important factor of creative photography. Once perceived, the subject's expression — a moment of pause between facial movements — may be fleeting and evade the most rapid shutter-release impulse. Awareness of the subject's personality enables some of us to *anticipate* expressive moments, not merely recognize them in passage. This, of course, requires both extensive practice and experience.

I have found that the continued use of artificial lighting may become repetitious and monotonous; the pictures may acquire a similarity in effect and feeling, and, in a sense, they all begin to look alike. In the past portraiture has often been taught primarily in a "studio style" formula: front-lighting, back-lighting, top-lighting, "Rembrandt-lighting," and so forth, with the application of various spot or diffuse fixtures, reflectors, changes of background, and numerous conventional poses. Little attention was given to portraiture under natural light. I do not believe in formulas; it is imperative to apply lighting that is appropriate for each subject. In fact the subject and the light illuminating it are quite inseparable, and the total effect can range from distressing to wonderful. With natural or available artificial light, our primary control consists of using screens or reflecting devices. Obviously it does not require much control to impair the natural-light quality.

The Anspacher experience encouraged

me to make a number of other portraits by similar methods, including ones of Phyllis Bottome, the English novelist, and the painter Foujita. After a year or so I realized that the repetition of effect was limiting, and I returned to natural light for my portraits whenever possible.

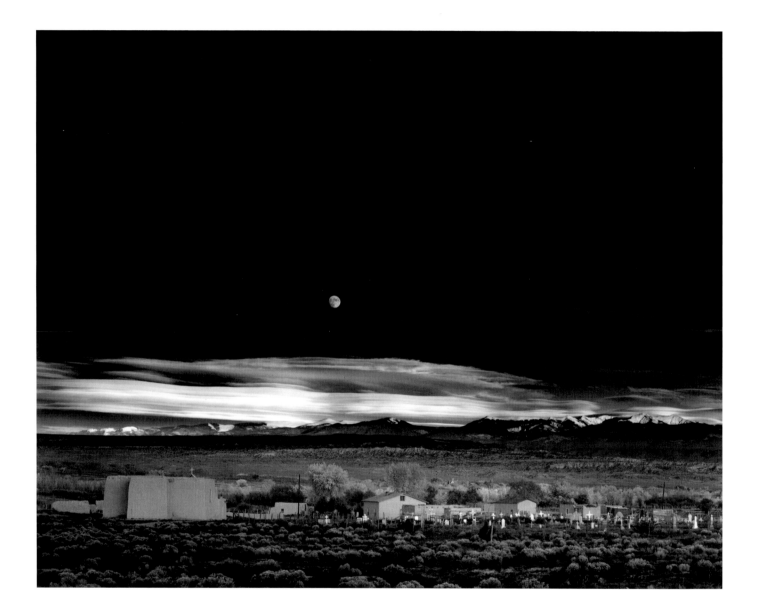

Moonrise

Hernandez, New Mexico, 1941

The making of this photograph — it is certainly my most popular single image — combined serendipity and immediate technical recall. I felt at the time that it was an exceptional image; there seems to be an almost prophetic sense of satisfaction when the shutter is released for certain exposures.

I had been photographing in the Chama Valley, north of Santa Fe. I made a few passable negatives that day and had several exasperating trials with subjects that would not bend to visualization. The most discouraging effort was a rather handsome cottonwood stump near the Chama River. I saw my desired image quite clearly, but due to unmanageable intrusions and mergers of forms in the subject my efforts finally foundered, and I decided it was time to return to Santa Fe. It is hard to accept defeat, especially when a possible fine image is concerned. But defeat comes occasionally to all photographers, as to all politicians, and there is no use moaning about it.

We were sailing southward along the highway not far from Española when I glanced to the left and saw an extraordinary situation — an inevitable photograph! I almost ditched the car and rushed to set up my 8×10 camera. I was yelling to my companions to bring me things from the car as I struggled to change components on my Cooke Triple-Convertible lens. I had a clear visualization of the image I wanted, but when the Wratten No. 15 (G) filter and the film holder were in place, I could not find my Weston exposure meter! The situation was desperate: the low sun was trailing the edge of clouds in the west, and shadow would soon dim the white crosses.

I was at a loss with the subject luminance values, and I confess I was thinking of bracketing several exposures, when I suddenly realized I knew the luminance of the moon — 250 c/ft^2. Using the Exposure Formula,[1] I placed this luminance on Zone VII; 60 c/ft^2 therefore fell on Zone V, and the exposure with the filter factor of 3x was about 1 second at f/32 with ASA 64 film. I had no idea what the value of the foreground was, but I hoped it barely fell within the exposure scale. Not wanting to take chances, I indicated a water-bath development for the negative.[2]

Realizing as I released the shutter that I had an unusual photograph which deserved a duplicate negative, I swiftly reversed the film holder, but as I pulled the darkslide the

sunlight passed from the white crosses; I was a few seconds too late! The lone negative suddenly became precious. When it was safely in my San Francisco darkroom I did a lot of thinking about the water-bath process and the danger of mottling in the sky area as a result of the print's standing in the water without agitation. I decided to use dilute D-23[3] and ten developer-to-water sequences, 30 seconds in the developer and 2 minutes in the water without agitation for each sequence. By using ten developer-water cycles I minimized the possibility of uneven sky.

The white crosses were on the edge of sunlight and reasonably "safe"; the shaded foreground was of very low value. Had I known how low it was I would have given at least 50 percent more exposure (a half zone). I could then have controlled the value of the moon in development, and the foreground would have a slight — but rewarding — increase of density.

The negative was quite difficult to print; several years later I decided to intensify the foreground to increase contrast.[4] I first refixed and washed the negative, then treated the lower section of the image with a dilute solution of Kodak IN-5 intensifier. I im-

mersed the area below the horizon with an in-and-out motion for about 1 minute, then rinsed in water, and repeated about twelve times until I achieved what appeared to be optimum density. Printing was a bit easier thereafter, although it remains a challenge.

There were light clouds in a few areas of the sky, and the clouds under the moon were very bright (two or three times as bright as the moon). I burn-in[5] the foreground a little toward the bottom of the print. I then burn along the line of the mountains, keeping the card edge in constant motion. In addition, I hold the card far enough from the paper to produce a broad penumbra[6] in its shadow; this prevents a distinct dodging or burning line, which would be very distracting. I also burn upward a bit to the moon to lower the values of the white clouds and the comparatively light horizon sky. I then burn from the top of the moon to the top of the image with several up-and-down passages.

It is difficult to make prints from this negative that I truly like; papers differ, toning sometimes gives unwanted density changes, etc. It is safe to say that no two prints are precisely the same.

Because of my unfortunate disregard for

the dates of my negatives I have caused considerable dismay among photographic historians, students, and museums — to say nothing of the trouble it has caused me. *Moonrise* is a prime example of my anti-date complex. It has been listed as 1940, 1941, 1942, and even 1944. At the suggestion of Beaumont Newhall, Dr. David Elmore of the High Altitude Observatory at Boulder, Colorado, put a computer to work on the problem. Using data from a visit to the site, analysis of the moon's position in the photograph, and lunar azimuth tables, he determined that the exposure was made at approximately 4:05 P.M. on October 31, 1941.[7] That is now the official date. I will never be so exact with my thousands of moonless pictures!

This photograph has undoubtedly evoked more comment than any other I have made and represents an unusual situation of content and effect. I am sure that the image would command general interest for the subject alone. It is a romantic/emotional moment in time. I think it would have a certain appreciation even if poorly printed. However, the mood of the scene requires subtle value qualities in the print that I feel are supportive of the original vis-

ualization. The printed image has varied over the years; I have sought more intensity of light and richness of values as time goes on.

1. Book 2, pp. 66–67.

2. Book 2, pp. 229–232.

3. Book 2, p. 253.

4. Book 2, pp. 235–237.

5. Book 3, pp. 102–110.

6. Book 3, pp. 105–107.

7. For a description of Dr. Elmore's methods, see *American Photographer*, January 1981, pp. 30–31.

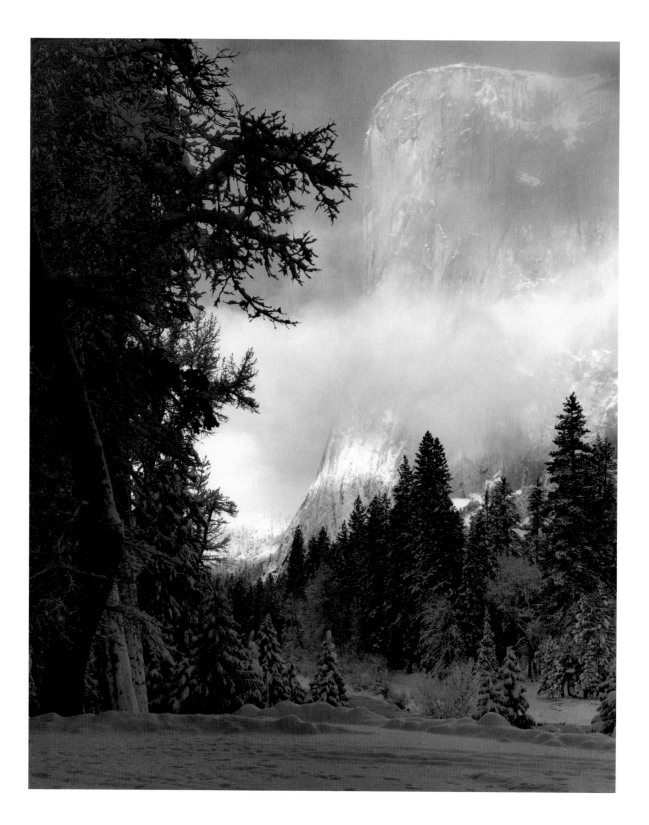

El Capitan, Winter Sunrise
Yosemite National Park, 1968

Getting up at dawn on a winter morning and driving around Yosemite in search of photographs is a chilly but wonderful experience. At the close of a snowstorm the trees are frosty white, but soon after the sunlight strikes them the snow falls in glittering cascades, and the oaks are soon bare and the pines green again. On this particular morning the clouds persisted longer than usual. I felt that El Capitan might be beautifully revealed as the clouds and mist swirled around it, and I was not disappointed. An additional heavenly generosity was a high-altitude haze that kept the high contrast in abeyance.

Arriving at the classic El Capitan viewpoint (because of forest proliferation, few of these grand Yosemite prospects remain today), I found the subject tremendously exciting. The snow was deep under foot, and it is not easy to get the tripod securely placed in such conditions; if the legs are not pressed through the snow to the ground or firm lower levels of snow and ice, they may slowly settle and move the camera out of position.

With the Schneider 121mm Super Angulon lens on my 4×5, I could contain the full reach of the 3000-foot cliff. The coverage of this lens[1] permits considerable camera adjustment, and I was able to keep the camera back parallel with the trees and cliff and use the rising front, avoiding convergence of the pines in the middle distance.[2] The clouds were swift-moving, and I made a series of exposures. There is no way one can anticipate accurately the positions of such wreathing vapors; one situation appears worthy of an exposure — and then appears another situation that seems even better. I made about six exposures on the film remaining in a Kodak Tri-X pack, then turned to the Polaroid Type 55 P/N material.

I was familiar with the Polaroid film and knew the effective speed of the Type 55 P/N negative (this film produces both a print and a negative, but they have different effective film speeds).[3] I made an exposure and tried to process it in the car. The solutions (sodium sulfite clearing bath and water for storage) were very cold, as was the film by the time it was put in the camera, exposed, and carried to the car. As a result, the integral chemistry could not function properly. I realized that I must carry

45

the Polaroid exposures back to my Yosemite darkroom and process them under favorable temperature conditions. I made several more exposures, feeling that I had really accomplished something, and then drove away — exploring a few futile situations on the way home. There, after processing, I found that all the exposures were acceptable, but two were of exceptional moments of the ever-changing scene.

The mood of the scene was dramatic and called for a deep-valued image — a literal rendition of values would not do at all! While the illumination was less contrasty than such a scene usually is, it was decidedly not soft. The Polaroid Type 55 negative has a shorter exposure scale than conventional film, and therefore higher effective image contrast. There is no control in processing, and only pre-exposure will help reduce contrast under certain conditions.[4] I visualized the opalescent glow of sun on the icy cliff; to stress this quality the shadowed surround of the forest must be rendered rather deep in value. With the Tri-X film I placed the forest on Zone II of the exposure scale. The high values fell on Zones VII–VII$\frac{1}{2}$, and the contrast was

slightly enhanced in printing. With the Polaroid Type 55 P/N film (exposing for the negative), I placed the shadows on Zone III, and the high values fell near the top of the exposure scale. The image reproduced here is from a Polaroid negative, which had the best cloud-cliff relationship and fine tonal values. The print was made on Oriental Seagull Grade 3, developed in Kodak Selectol-Soft with some Dektol added.[5]

A viewer once asked me about the values: "Don't you think the trees are rather dark?" Black-and-white photography gives us opportunity for value interpretation and control. In this instance, were the trees lighter in value, the glow of light on the cliff would, for me, be far less expressive. Exposing for higher forest values would have weakened the separations of the far brighter cliff and cloud values. However, other photographers might well make quite different images. I would not like anyone to think I believe this image to be the only one possible, but it fulfills my visualization at the time of exposure. In an overpowering area such as Yosemite Valley it is difficult for anyone not to make photographs that appear derivative of past work. The sub-

jects are definite and recognizable, and the
viewpoints are limited. It is therefore all
the more important to strive for individual
and strong visualizations.

1. Book 1, pp. 54–55.

2. Book 1, pp. 143–144.

3. *Polaroid Land Photography,* pp. 45–48.

4. *Polaroid Land Photography,* pp. 146–151.

5. Book 3, pp. 93–95.

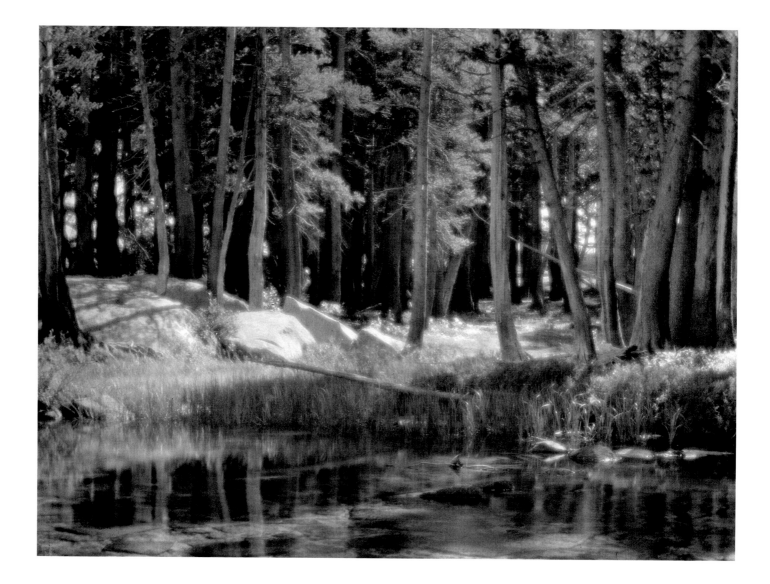

Lodgepole Pines

Lyell Fork of the Merced River, Yosemite National Park, c. 1921

In the early days I experimented with many of the ways and means of photography on a rather haphazard basis. Photographic education was practically nonexistent, especially on the West Coast of the United States. Some high school chemistry and physics classes considered photography in its practical aspects, but certainly not in its expressive potentials. The Pictorialists of this period thought they represented the Art of Photography (and many still think so), and their knowledge of photographic techniques was transmitted to dilettante photographers through camera clubs and popular magazines. The Pictorialists seemed dedicated to the proposition that a photograph should not look like a photograph, but like some other form of graphic expression.

In these early days amateurs of my kind experimented with a variety of processes and equipment. We read all the photographic magazines we could obtain, and acquired much disorganized information, some of which was nevertheless helpful. The magazines of that period were, I recall, more informative than the popular publications of the present. They were addressed to the amateur (mostly the Pictorialist), and, of course, the style we now think of as "creative" photography hardly existed. During this period I made prints on many papers and produced several bromoils (a rather complex technique of superior quality when mastered). I tried pinhole photography[1] and explored the soft-focus lens possibilities. The image discussed here is one of my early efforts with soft-focus technique.

The effects of soft-focus lenses are not always understood. The lens itself retains a large amount of spherical aberration[2] and may also have color-transmission (chromatic) aberrations. As the lens is stopped down, aberrations are reduced and the image becomes sharper. Lenses were obtainable not too many decades ago that had diffusion effect at wide apertures but were quite sharp at the smaller lens stops (Graf-Variable, Hugo Meyer Satz Plasmat, etc.).

The softness produced with these lenses on the camera is noticed mostly in the flare of light from the high values of the image, and specular reflections give the most pronounced effect. The illusion can be one of shimmering light, often a rewarding optical

effect. In enlarging, if a soft-focus lens is used, or a diffusing device is placed over the lens, it is the *dark* areas and edges of the image that are flared, and, in my opinion, the effect is generally quite unpleasant. Hasselblad makes several lens attachments (known as Softars) offering different degrees of diffusion. I have found that their effect is not exactly the same as with soft-focus lenses, since differences in diffusion are slight as the lens aperture is reduced. Note that the use of diffused light sources in enlargers bears no relation to the diffused effect of soft-focus lenses. Soft-focus lenses cause scattering of the light that is focused to form the image. The enlarger light source is diffused *above* the negative, so the image sharpness is not impaired. The effect of a diffusion light source is to give less harsh contrast and preserve separation of the high values, compared with undiffused (condenser) lighting.

On a pack-trip in the Merced River Sierra about 1921, I was using a $3\frac{1}{4} \times 4\frac{1}{4}$ Zeiss Mirrorflex (an early single-lens reflex not unlike the Graflex) to which I could attach an f/5.6 Portland soft-focus lens of about $8\frac{1}{2}$-inch focal length. The lens was in its original barrel and the focal-plane shutter of the camera provided fairly reliable exposures up to $\frac{1}{100}$ second. As I recall, the exposure for this photograph was $\frac{1}{50}$ second at f/8. I have forgotten the make of film or its effective speed. The negative enlarges well to about 8×10 inches; beyond that the image becomes rather gross.

Edward Weston once remarked that he would not reject a print made on a bathmat, providing it was a *good* print. The miracles of creative art lie not in particular materials and methods, but in the basic concepts involved. I recall the bright sylvan occasion of making this photograph, but I cannot say *why* I responded to the scene. We all loved the land and our days in the mountains, but my companions would watch me struggle with some fragment of nature and shake their heads: "What in the world are you photographing *that* for?" A good friend — a man of great culture and intelligence — on first seeing my *Pine Cone and Eucalyptus Leaves*, took me aside and said, "Why don't you apply your talents to subjects that *mean* something?" This revealed to me that others did not see as I did, and I found that there was little use protesting their attitudes.

While I have never been sympathetic to

Pictorialist concepts, I have endeavored to discover what the photographers of this classification try to express. It is clear that the goal is to reflect closely the qualities of painting in photographs. These attempts are usually futile and inferior, for they betray the natural traits of our medium.

From its inception, photography has been treated as a stepchild by the other arts: decried as being capable of mere documentation rather than creative expression. The conflict between capitalism and communism is no less rigid than that which has raged between painters and photographers. The painters' complaint includes the argument that photography takes attention and space in museums and art departments from "real" art: painting!

As destructive as I believe the Pictorialist expression has been to our art, it is an attempt to see and say something, and this effort should not be ignored. In thinking of the myriad Pictorial photographs I have seen, one positive, dominant element was that of the impression of light, suggested by the diffused image produced by the requisite soft-focus lens. This quality is not a matter of delineation of line or texture, but of luminosity: light emanating as a glow from the surfaces of the subjects. This one aspect I find very important in principle and I intend to further explore its potential for my own photographs.

1. Book 1, pp. 3–6.

2. Book 1, pp. 74–77.

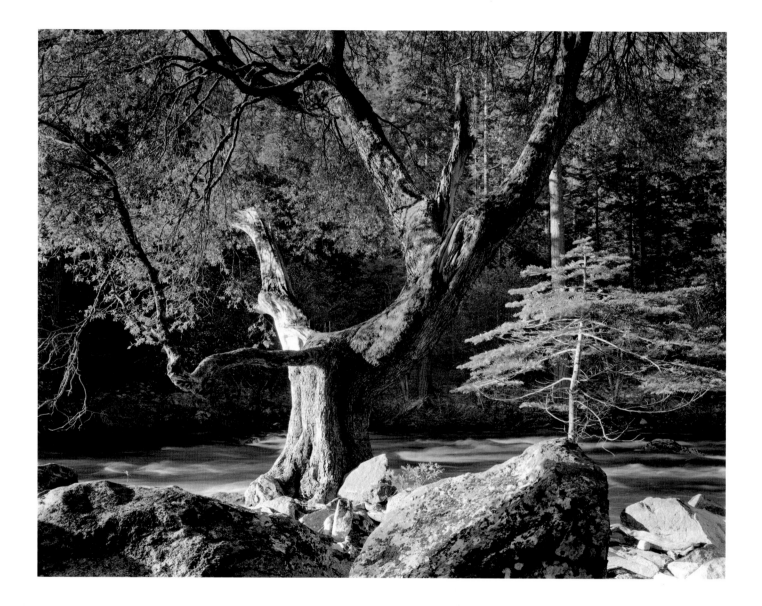

Early Morning, Merced River, Autumn

Yosemite National Park, c. 1950

This serene subject is only about one hundred feet from the highway; I have passed it hundreds of times, and I retain many "corner of the eye" memories of it at all times of the year. The shapes, even glimpsed from a moving car, were always beautiful, but the lighting conditions usually were impossible. On this morning I observed a situation I could not resist; a glance was enough to command me to stop, park my car, and carry my equipment to the scene. My eye enjoyed a wonderful impression of light in all areas, but it was a very high contrast subject for the film, and I recognized this problem as I was setting up the camera.

I was using my Kodak metal 8×10 view camera, of aluminum construction, designed as a replica of their standard wooden flatbed camera. It once belonged to the explorer Louise Boyd, who funded and directed several expeditions to Greenland. How an 8×10 camera was used on the difficult treks over the glaciers I do not know. I still have this camera, and it has always worked well for me. Most of the view cameras of today are of the monorail design and have more adjustments and more rigidity

than did the earlier flatbed models;[1] the latter, however, fold into more compact space than do monorail cameras.

Setting up the camera was difficult; the ideal vantage point was from a rugged assembly of granite rocks. Each tripod leg had to be adjusted not only for the desired viewpoint but for security of the camera. I had a difficult footing and it was not easy to scan the entire groundglass and observe the relationships of foreground to background objects as well as the desired borders of the image. My horizontal framing was right, but I moved the camera-bed back about ten inches to slightly reduce the image size of the nearby rocks and trees. The 10-inch Kodak Wide-Field Ektar was just right for the situation, and no filter was required.

The picture was made just after sunrise, which at this spot is an hour or more after true sunrise because of the high surrounding cliffs. Fortunately there was no wind; the required exposure was about $2/5$ second at $f/45$, with a film of ASA 125 speed. With this shutter the slow speeds were a little fast. I set it at $1/2$ second, and the fast-moving water was blurred, as expected.

With normal development the subject

luminance range would have been excessive, and hence Normal-minus-one developing time seemed appropriate. The image was correctly exposed, but with minus development the texture-contrast of the low values was weakened.[2] Fortunately, when I think I have an exceptional image, I make two identical exposures.

With the second negative I used the water-bath process. I should have realized from the start that water-bath development was indicated to better support the shadow values.[3] The water-bath process holds the high values but also sustains the local contrast of the low (shadow) values, giving an impression closer to the visual experience. Today, with modern thin-emulsion films, a highly dilute developer solution[4] or the two-solution process[5] seems about equally effective, and both approach the control that was once so rewarding with the water-bath process.

The lowest luminance of the foliage across the river (about 5 c/ft^2) was placed on Zone II,[6] and the highest textured values of the sunlit tree and rock (about 500 c/ft^2) fell about on Zone VIII$\frac{1}{2}$. There was no total black in any part of the scene; the print shows detail in the darkest shadow area, and texture is also revealed in the lightest high values. In the print the darkest shadows are brought down to almost full black to preserve a good foundation value, and the whites are on the edge of texture. A soft print would not represent the crisp morning mood of the subject. In the usual reproduction processes the deep shadows and highest values are not fully revealed, but the original print contains them all.

I try to avoid describing how I visualize a photograph because of the failure of words to convey the qualities of expressive images. I can, however, attempt to recall the sequence of procedures. I had been aware of this subject many times while traveling in and out of Yosemite Valley. I am sure the image developed in my unconscious mind over time; on the morning the picture was made I recognized the desired image immediately. All the components fell into place in terms of form and value. The mood of the image was established and visualized intuitively. I had no difficulty (except physical) in selecting the point of view. The use of the 10-inch Ektar lens, rather than the 12$\frac{1}{4}$-inch Cooke, was automatic, as I was

aware of the fields of view covered by each. Reading the meter, checking focus, planning the exposure and development, and so on, were all swiftly accomplished, and at an intuitive level. This facility comes from extensive practice and constant thinking in terms of images. The final print reveals the craft, as well as the interpretation of what was seen and felt at the moment of exposure.

I am always visualizing image possibilities in the world around me, trying to relate shapes and values in whatever I see before me in terms of a format and image qualities the way the camera, not just the eye, "sees." The shapes of the external world are resolved into the forms of the image. I am not a strict observer of the established formats — 35mm, $2\frac{1}{4} \times 2\frac{1}{4}$, 4×5, 5×7 and 8×10-inch, etc. — as the world is seldom designed to such proportions. The photographer does not have the capabilities of the painter to adjust his compositions to standard formats, or to combine impressions in a single image. Those who work with multiple printing (combining different negatives in one print) may dispute this statement. However, I am referring to the single, clear and intense statement of the direct photographic image. Such images must be visualized in whatever is their optimum format, and judicious cropping used to fulfill the visualization.

1. Book 1, Chapter 4.

2. Book 2, pp. 80–83.

3. Book 2, pp. 229–232.

4. Book 2, pp. 226–228.

5. Book 2, pp. 229–232.

6. Book 2, pp. 57–59.

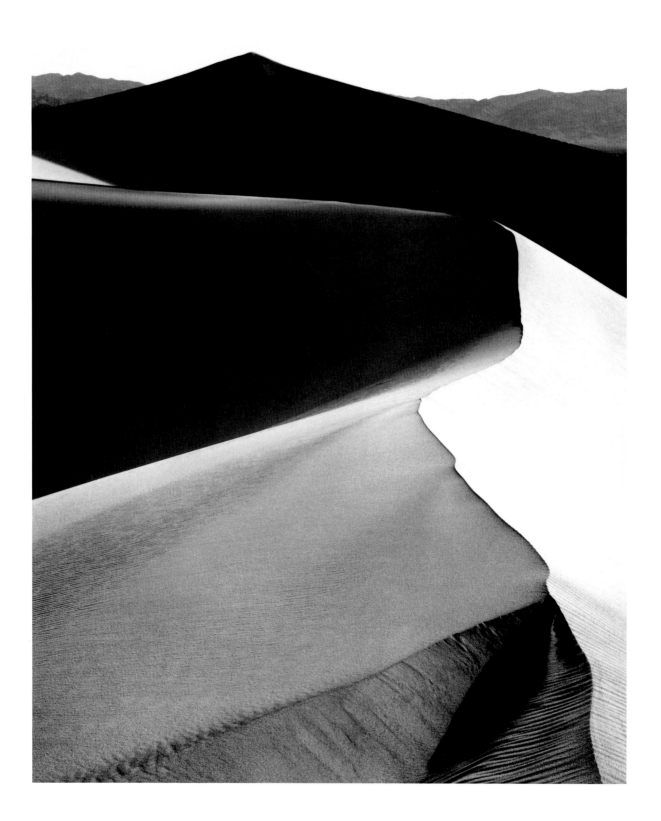

Sand Dunes, Sunrise

Death Valley National Monument, California, 1948

For most photographers Death Valley presents difficulties. The desert experience is primarily one of light; heroic, sunlit desolation and sharp, intense shadows are the basic characteristics of the scene. It is a region where early morning and late afternoon lighting conditions are usually the most favorable. On the other hand, Edward Weston did many of his finest photographs there in the blazing light of midday. He appreciated the subtle variations of values under flat sunlight.

Edward's first visit to Death Valley resulted in a number of failures. He used a strong yellow filter, thinking that such would separate earth and sky. He did not realize that yellow and reddish earth photographed with a yellow filter (like the Wratten No. 8, K2) will be overexposed if the normal filter factor[1] is used, because filters pass their own color freely.[2] He discovered that using the filter with *no* filter factor caused the earth to retain its inherent values, but the blue sky and the bluish shadows were definitely lowered in value. I thanked Edward for this information; on my first trip to Death Valley I followed his suggestions with considerable success.

With quite distant scenes it is necessary to reduce the haze effect of the great masses of air between subject and camera, and strong filters may be required.

In many desert photographs of sunlit subjects, the shadows appear as empty black areas. This is visually untrue; the eye perceives great luminosity and texture in these areas. With average exposure the shadows may fall near the bottom of the exposure scale, thus approaching solid black. We should thus visualize the desired shadow values and adjust exposure and development of the negative thereto.

I was camped in my car near Stovepipe Wells, usually sleeping on top of my car on the camera platform, which measured about 5×9 feet. Arising long before dawn, I made some coffee and reheated some beans, then gathered my equipment and started on the rather arduous walk through the dunes to capture the legendary dune sunrise. Several times previously I had struggled through the steep sands with a heavy pack only to find I was too late for the light or I encountered lens-damaging wind-blown sand. The dunes are constantly changing, and there is no selected

place to return to after weeks or months have passed.

A searing sun rose over the Funeral Range, and I knew it was to be a hot day. Fortunately I had just arrived at a location where an exciting composition was unfolding. The red-golden light struck the dunes, and their crests became slightly diffuse with sand gently blowing in the early wind. To take full advantage of the sunrise colors on the dunes I worked first with 4×5 Kodachrome, placing the sunlit values on Zone VI with no color-compensating filter or polarizer. Then, without moving the camera, I made several exposures with black-and-white film. The luminance of the sunlit dunes was placed on Zone VI of the exposure scale. I used a Wratten No. 8 (K2) filter without filter factor and indicated Normal-plus-one development.[3]

The effect of the exposure placement and the No. 8 filter was to deepen the shadows, which were illuminated by light from a very blue sky, and to clarify the distant mountains. The horizon sky, however, was extremely bright and displayed a blue of very low saturation; it was hardly affected by the filter, and is rendered as a very light gray. I like this effect because it conveys the impression of light. The horizon sky is almost pure white in the color photograph.

The image has a vigorous design and a fairly good scale. Because I used a 7-inch Dagor lens, I did not get the exaggerated near-far effect of perspective that a shorter focal length would have allowed. I did tilt the camera back a little to assure focus on the foreground ripples of sand and the distant dune and mountains. The exposure was $1/8$ second at f/22–32 on Kodak Plus-X filmpack film at ASA 64.

Within fifteen minutes the light flattened out on the dunes, and I moved back to my car through 90°F and more of Death Valley heat. I was thankful for the white focusing cloth and the white camera cases. I recall previous summer trips in the Sierra where my camera cases and their contents became alarmingly hot in direct sunlight. The ambient air temperature was tolerable, but the heat generated within the black or dark-colored cases was severe. An experiment confirmed the value of white protective paint, white fabric, or aluminum. I had two identical black fiber cases, one of which I painted white. These were placed

in direct sunlight with a thermometer in each. In fifteen minutes the painted case gained only ten degrees Fahrenheit; the unpainted case soared to 125 degrees — and this on a mild sunny noon in San Francisco! I could imagine how hot the black case could become in the blistering desert. Manufacturers continue to produce dark cases and bags, and focusing cloths with both sides dark. Obviously, their designers have never worked in the desert!

I give full credit to the excellent scientists and technicians involved in the photographic industry. The research, development, and design aspects, as well as production, are extraordinary. However, very few photographic manufacturing technicians comprehend photography as an art form, or understand the kinds of equipment the creative person requires. The standards are improving in some areas, however: in my opinion modern lenses approach the highest possible levels of perfection, and today's negative and printing materials are superior to anything I have known and used in the past. I am sure the next step will be the electronic image, and I hope I shall live to see it. I trust that the creative eye will continue to function, whatever technological innovations may develop.

1. Book 2, p. 116.

2. Book 2, p. 99.

3. Book 2, pp. 71–79.

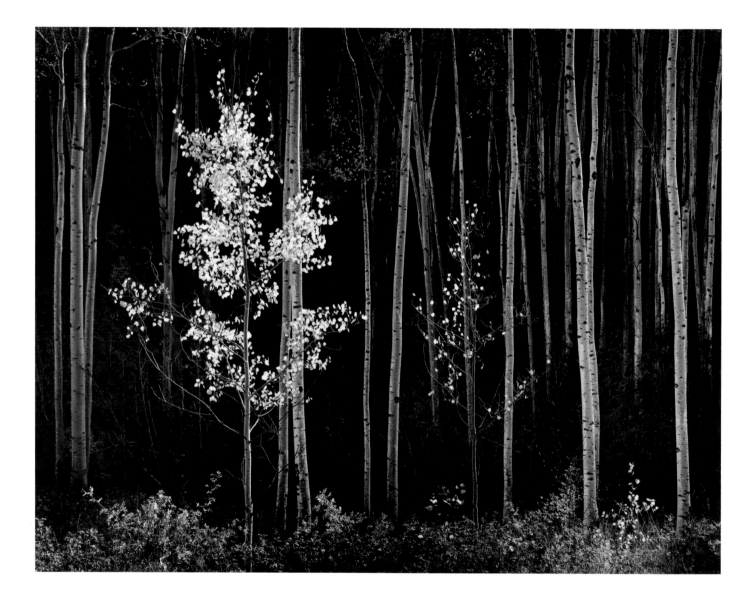

Aspens
Northern New Mexico, 1958

I made these two photographs within an hour of each other on a crisp autumn day in the mountains north of Santa Fe. Gerry Sharpe and Don Worth (both at that time my assistants), my wife, Virginia, and I were driving on the beautiful highway near the crest of the Sangre de Cristo mountains, and we came across a stand of young aspen trees in mellow gold. I immediately knew there were wonderful images to be made in the area, and, within a few minutes, a few feet from the parked car, we three photographers were busy with our particular visions.

Working with my 8×10 camera I found that I gained the best optical image with the 19-inch component of my Cooke Series XV lens. From the near side of the road the 12¼-inch focal length gave an agreeable image size of the trees, but the angle of view included too much of the leafy canopy of the grove and disturbing small areas of the sky. One problem with forest scenes is that random blank areas of sky seen through the trees can confuse the spatial and tonal continuum of the composition. In reality such interruptions are logical and accepted, but in a photograph they can be extremely distracting. The sky is usually much brighter than foliage, and these bits of blue sky can be considerably overexposed and blankly white. With the 19-inch lens I could move to the far edge of the road. The grove was at the base of a steep rise of land, and from this position no disturbing bits of sky intruded behind the continuous patterns of branches and leaves.

We were in the shadow of the mountains, the light was cool and quiet and no wind was stirring. The aspen trunks were slightly greenish and the leaves were a vibrant yellow. The forest floor was covered with a tangle of russet shrubs. It was very quiet and visually soft, and would have been ideal for a color photograph, with appropriate color-compensating filtration to remove the blue-cyan effect of the light from the blue sky.

In black-and-white photography, normal exposure and development would have produced a rather flat and gray image. I visualized the images as stronger, in accord with the mood of the hour and place. The colors of nature are of low saturation, and this often includes visually bright autumn leaves. I felt that a deep yellow Wratten

No. 15 (G) filter would be appropriate. I knew it would reduce the shaded ground values, thereby enhancing the general contrast of the subject (ambient light was mostly from the blue sky). Strong side lighting from banks of brilliant clouds on both left and right provided most favorable illumination of the nearly white tree trunks.

I placed the deepest shadow on Zone II and indicated Normal-plus-two development time. I selected pyro[1] as the appropriate developer for this subject, because I knew it would give high acutance to the glittering autumn leaves. I knew I must use a higher-than-normal paper contrast for printing, since the highest values of the leaves fell on about Zones VI–VI½. As I recall, the exposure, with the No. 15 filter (factor of 3), was 1 second at f/32 on Kodak Panatomic-X film at ASA 32. With no wind this relatively long exposure was possible; had the aspen leaves been quaking I would have had a severe problem.

Both images reproduced here were exposed the same and received the same amount of development. I made the horizontal picture first, then moved to the left and made the vertical image at about the same subject distance. The few yellow leaves seen in the vertical image were not as bright as those in the horizontal version, and I could have increased the exposure.

The two images were quite satisfying statements. Beautiful as the grove was I saw no other compelling photographs. I am sure that if I returned under different conditions new concepts would stir my attention.

The printing of these two images is exacting; there is a very subtle difference between "too dark" and "too light." The appropriate values in an untoned print may become much too dark with even moderate toning. In very large prints (30×40 and 40×60 inches) the horizontal image reveals worm holes in the bright leaves, visible largely because of the high acutance property of the pyro developer. These probably would have been obscured if I had used a developer, such as Kodak D-23, which gives lower acutance than pyro.

These photographs are exceedingly popular at all levels of appreciation. I do not consider them "pretty" scenes; for me they are cool and aloof and rather stately. In black-and-white they contain a full range of values; a color photograph (as I thought of

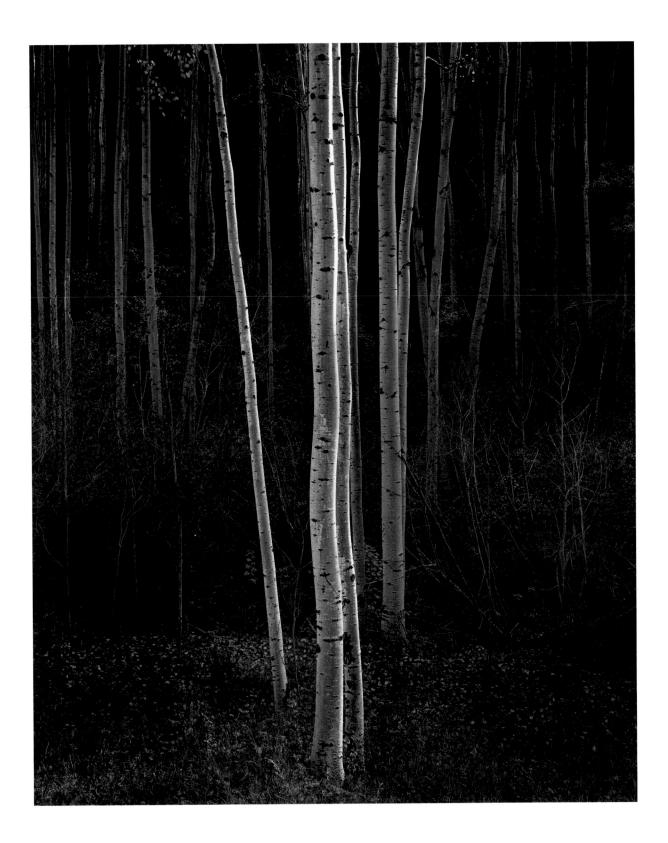

one at the time) would be very delicate, with quiet opalescent hues.

The majority of viewers of the horizontal image think it was a sunlit scene. When I explain that it represented diffused lighting from the sky and also reflected light from distant clouds, some rejoin, "Then why does it *look* the way it does?" Such questions remind me that many viewers expect a photograph to be the literal simulation of reality; of course, many others are capable of response to an image without concern for the physical realities of the subject. Either the photograph speaks to a viewer or it does not. I cannot demand that anyone receive from the image just what was in my visualization at the time of exposure. I believe that if I am able to express what I saw and *felt,* the image will contain qualities that may provide a basis for imaginative response by the viewer.

1. Book 2, p. 233.

Mount Williamson

Sierra Nevada, from Manzanar, California, 1944

I made this photograph on one of my several trips from Yosemite to the Manzanar Relocation Camp in the Owens Valley of eastern California. The infamous decision of the government (in the time of fear and hysteria following Pearl Harbor) to transport American citizens of Japanese ancestry to several detention camps resulted in most severe hardship among the Japanese-American population of the West Coast. In the first days of the exodus, Dorothea Lange was among those who photographed the misery and bewilderment of the Japanese-Americans as they were taken to the tarpaper shacks in the desert. Her photographs are shocking, moving documents of a terrible time for those people. I came on the scene several years later, when the relocation camps had been made more livable and functional by the efforts of the inhabitants themselves. Dorothea's earlier photographs of this tragic event have priceless historical value; mine (published in *Born Free and Equal*)[1] were an attempt to record the accomplishment of the people in rising above their desolate situation.

I was invited to Manzanar by my old friend Ralph Merritt, who had just been appointed director of the camp, to photograph the people and their environment. Ralph Merritt was an enlightened man and administered the camp with compassion for the uprooted citizens. I have believed that the setting of this camp, no matter how desolate the immediate desert surround, was a strengthening inspiration to the people. The enormous backdrop of the Sierra Nevada to the west and the high desert ranges to the east gave the nature-loving Japanese-Americans a certain respite from their mood of isolation and concern for the future. Many spoke to me about this; under guard some were permitted to go into the mountains and gather stones and plants for the Japanese garden they constructed in the desert. With their farms, schools, churches (Buddhist, Christian, and Shinto), cultural studies and events, and playgrounds, they relieved the monotony of farming and of the small industries developed in the shacks in which they lived.

It is a grand view of the Sierra from the camp; the main peaks rise more than eleven thousand feet above the desert floor. When the opportunity presented I would work in the Owens Valley environment, making some of my best photographs of 1943–1945 within and close to Manzanar.

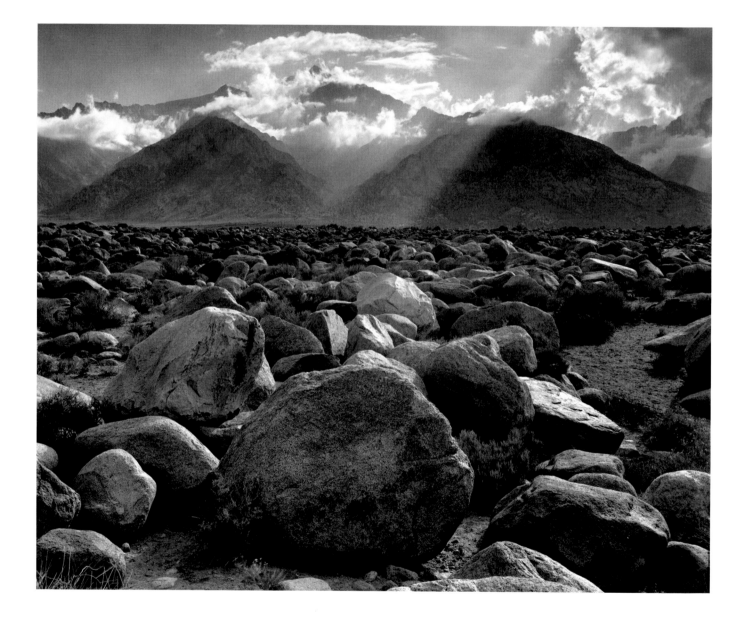

Traveling around the valley, I could see and recognize on the western skyline the distant Sierra peaks I knew intimately from my mountain travels in earlier years.

The eye and mind gather the splendors of this region into wonderful ideas and anticipatory visualizations. Our eyes scan only a small angle of view at any moment; as we move our direction of sight, our visual memory holds and builds impressions of larger and larger areas, while bringing each point concentrated upon into clarity and detail that only a very long-focus lens will approximate. The Sierra slopes back from desert edge to summit at an angle of forty-five degrees or less; seen from a frontal distance it appears as a gray rise of land engraved with clefts and gorges of vast proportions. Early morning shadows give way to flat sun glare; this, in turn, yields to the complex confusion of mid-day sun and shadow, which is better remembered in the mind than on film. In the afternoon the shadows lengthen and the range finally becomes a giant wall of subtle textures and jagged crests.

I have found that very long-focus lenses can explore distant mountains in great detail, but the photographic problem reminds me of eye-wandering over a complex tapestry surface, seeking small areas of intrinsic good composition and interest. Unless covered with winter snow, the granite and metamorphic rock blends gently with the near-horizon sky. Seldom agreeable with color photography and usually disappointing in black-and-white, such conditions cry for near-far compositions of significant foreground, with the mountains relegated to non-dominant proportions in the image.

When the clouds and storms appear the skies and the cloud-shadows on the mountain bring everything to life; shapes and planes appear that were hitherto unseen. Mountain configurations blend with and relate to those of the clouds. Paul Strand said to me at Taos, at my meeting with him in 1930 that was of such importance to my photography: "There is a certain valid moment for every cloud."

At the west border of the Manzanar area a vast field of boulders extends to the base of Mount Williamson, several miles away. The East Peak of Williamson (more than 14,000 feet above sea level) rises in rugged cliffs and gorges of barren stone. It is difficult to photograph on the ordinary bright, clear desert days, as the value of the rock

may blend with that of the sky. But in days of storm it is magnificent, especially under the thunderstorms of summer. It seldom rains in the Owens Valley, but the huge clouds and curtains of rain over the summits are spectacular.

On one of these days I drove my station wagon to a place I had often visited. Never before had the conditions been right for me at this location, but this time there was a glorious storm going on in the mountains. I set up my camera on the rooftop platform of my car — 8×10 view camera, with a Cooke Series XV lens (a 12¼-inch triple convertible with components of 19- and 23-inch focal length). The platform view is rewarding in flat country; it enabled me to get a good view *over* the boulders to the base of the range. I pointed the camera down a little and tilted the back to hold both the near rocks and the distant peaks in sharp focus.[2] Several times I moved the car a few feet to position the camera precisely for the composition of boulders and peaks.

When the sun shone through the afternoon clouds on the boulders, the shadows were very intense. The clouds near the sun were extremely bright. With my S.E.I. Exposure Photometer I was able to read small areas of the subject: clouds near the sun registered about 4000 c/ft^2 and the near dark shadows about 10 c/ft^2. This early spot meter remains a marvelous accessory. It is not as simple as the contemporary electronic meters and it is hard to read in strong sunlight unless the eye is carefully shielded; but it is, nevertheless, a very sensitive and accurate device.

The exposure range was considerable, and I knew I had a problem. I placed the deepest shadow values on Zone I; the highest cloud values fell above Zone X. With Kodak Super-Panchro Press film (ASA 200) and a Wratten No. 15 (G) filter, the exposure was ¹⁄₁₀ second at f/32.

With this high-contrast image I felt that Normal-minus-two development was required. On second thought I realized that ordinary minus development, while holding the extreme values within printable range, would weaken the separations in the shadows and low-middle values. Accordingly, I indicated water-bath development, which not only holds the high values within printable range, but also strengthens the shadow-area contrasts.[3]

I sometimes make sequences or duplicates with an important subject, and I

made several negatives of this scene. In all but one the cloud positions and the lighting on the mountains were not satisfactory and the negatives were discarded.

Printing this negative is not simple; I prefer to use a paper such as Ilford Gallerie Grade 2 with Dektol or Oriental Seagull Grade 2 with Selectol-Soft and Dektol stock solutions combined (500 cc Selectol-Soft stock, 1000 cc water and 100 cc Dektol stock).[4] A generous toning in selenium gives a fine solidity of tone.

This is a subject that invites too-strenuous printing. I have made many prints that are too heavy because, in trying for maximum richness, I simply over-printed them. I have also made prints that are too light, as a thoughtless rebound from the heavy images. It is important to test the papers carefully and be aware always of the dry-down effect.[5]

I have been interested in the comments this photograph inspires, from its being a "paste-up" to being a plagiarism of Wagnerian moods! I have been asked, "Is this a *real* photograph?" A badly enlarged blow-up was installed in the *Family of Man* exhibition at the Museum of Modern Art in New York (1955). A popular publicity photo-graph of this show was a picture of a child, facing the camera with arms fully extended, before the large foreground boulder; the rock was larger than his reach. It was a very literal and shallow idea and represented a questionable level of appreciation. As Queen Victoria remarked, "We are not amused."

1. New York: U.S. Camera, 1944.

2. Book 1, Chapter 10.

3. Book 2, pp. 229–232.

4. Book 3, pp. 93–95.

5. Book 3, pp. 82–84.

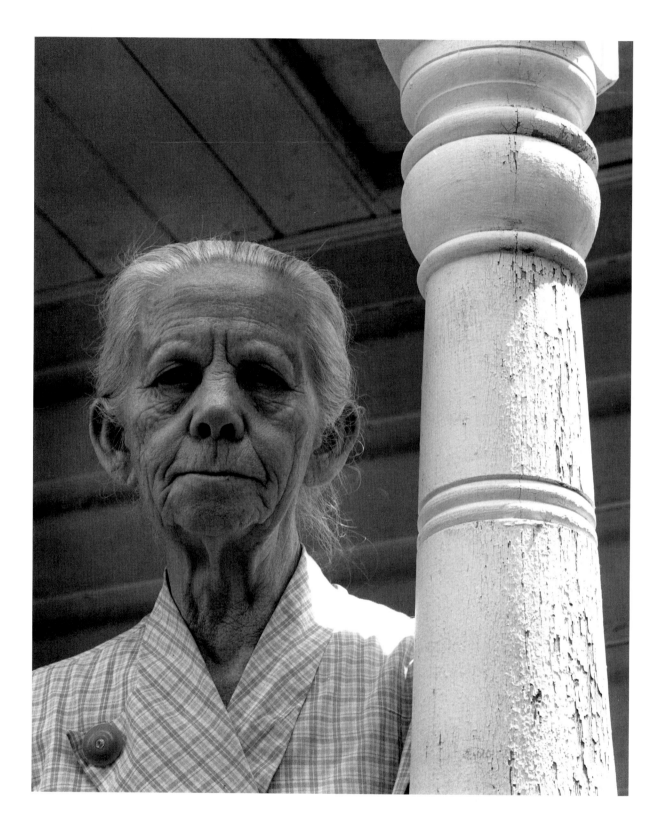

Martha Porter, Pioneer Woman

Orderville, Utah, c. 1961

The term "found object" has been used for many years in photography to indicate a subject photographed as it is found, untouched by the photographer. People are "found" as well as objects. Because of the inevitable mutual selfconsciousness, an assigned portrait is seldom as free as a spontaneous encounter with the subject. Some photographers, notably Minor White, have explored the personality of their subjects to establish a creative empathy that makes portraiture a mutual experience. I respond to people on an immediate and intuitive basis, and find it very difficult to photograph people who do not make me *want* to photograph them.

I was traveling through southern Utah with an open eye and mind and plenty of film. I had been invited to stay at the home of Maynard Dixon, a painter of the Southwest of great acclaim, and his wife, Edith Hamlin Dixon, also a fine artist. Their home was near Mount Carmel, in southern Utah — a wonderful center for exploring the landscape and villages of that exciting area. The Dixons advised that I visit the town of Orderville, near Mount Carmel: "Should be nice things there!"

Early the next morning I drove to Orderville. The dawn and sunrise are always rewarding in the Southwest, especially in autumn. I saw many beautiful things, but few exciting picture possibilities. The photographer should not allow himself to be trapped by something that excites him only as *subject*; if he does not see the *image* decisively in his mind's eye, the result is likely to be disappointing. I responded to a vigorous detail of a nearby barn, but I could not visualize an image and experienced a gnawing frustration.

I then observed a nice old home with white porch pillars catching the early sun. As I came closer I became aware of an elderly woman sweeping the porch and I immediately knew there was promise in the morning air. I asked if I could photograph her by the white pillar. She was most cordial and came to the porch railing, saying, "I don't know why, but go ahead." She reminded me a bit of Imogen Cunningham — very direct and a bit acerbic. I made a few negatives with my Hasselblad, thanked her, and promised I would send her a print (and did). I drove for many miles and saw much beauty around me, but no photographs. The day concluded happily with wine and dinner at the Dixons'.

Reconstructing the situation of this photograph I must say that the visualization was immediate and very clear. I felt a strong human and aesthetic motivation to begin with. The woman was in cool shadow, and the low-angle sun touched the noble white pillar. I saw the print about as you see it reproduced here. I measured the values of the face with my S.E.I. spot meter; they were between 20 and 35 c/ft², and I placed their average on Zone V.[1] The white pillar fell on Zones VII–VIII. Normal development was appropriate.[2] I used my Hasselblad with the 80mm Zeiss Planar lens, and Kodak Plus-X film at ASA 64. It was developed in Edwal FG7 for Normal time. It prints handsomely now on Oriental Seagull Grade 2, although at the time I made the negative I was using Kodabromide F Grade 2 or Brovira Grade 3.[3]

The picture haunts me. I have not yet made the print I desire. The tonal qualities of the woman's face please me, but I am not able to print through the blank sunlit area of her shoulder without getting a flat, textureless value, since the film is severely blocked[4] in that area. The face values require control with a small amount of dodging, not because the original placement was wrong but because of their relationship to the background of the porch wall and roof. These values were very close in terms of black-and-white photography, so close that I cannot conceive of any practical way to separate them other than by adding diffuse reflected light (which I had no means to do with this subject), or by discreet dodging of the face.[5] In color photography the value-relationships of skin and wall would be well defined; the lightly suntanned skin against the gray-white of the wall could be well interpreted. Actually, the porch walls and roof were as white as the pillar, but the face, while in shade, was in much stronger and more direct light from the open sky. The eye balances such differences far better than any film can manage. I knew I was facing a problem; if I had placed the face on a different zone, the merging with the porch values would have remained the same, but the values of the sunlit pillar would have changed. Experience and practice usually recognize such value-control problems, yet I admit I have failed on many occasions chiefly because I accepted the visual, rather than anticipating the film's response to values and colors.

Any aesthetic/emotional comment I can make on this photograph is not in any way as effective as what the print will tell about

itself. I recall the incisive morning light revealing the glowing values of the pillar and creating the cool luminance of the shadowed face and the space beyond it. We should not think of shadows as being areas of low contrast only; there can be considerable vitality in the lower values of the image. The face was illuminated chiefly from the sky, with some random reflected light from the sunlit earth. Trees and the overhanging porch roof created a rather narrow band of sky illumination (about 40° wide) at a fairly low angle.

How different this problem was from one of lighting a portrait in the studio! In viewing many portraits over the last sixty years I have often been impressed with the repetitive effects of artificial lighting. There is little of the magic of appropriately managed natural light. Now, with popular modern cameras, we create light from very near the camera axis with built-in flash computed for balanced intensity. Billions of pictures are made with the diabolically clever automatic cameras, pictures that satisfy the snap-shooter but do not often reveal evidence of imaginative visualization (there are some encouraging exceptions).

Look at photographs that were made before the age of electronic flash — even before the age of any artificial lighting. They often have extraordinary vitality and singularity. Such great photographers as Julia Margaret Cameron, Alfred Stieglitz, Edward Weston, and many others have affirmed the qualities of natural light. As Stieglitz said, "Wherever there is light one can photograph."

1. Book 2, Chapter 4.

2. Book 2, pp. 71–79.

3. Book 3, pp. 49–51.

4. Book 2, p. 62.

5. Book 3, pp. 102–110.

Mount McKinley and Wonder Lake

Denali National Park, Alaska, 1947

Clear weather in Denali National Park and in Glacier Bay National Monument is usually scarce in midsummer, and the photographer can expect to see horizons only in the sunrise and sunset hours, if then! At other times of day, however, he can turn his lens to the close and intimate aspects of the natural scene.

I prefer the Indian name, Denali, instead of Mount McKinley, and Denali is now the official name of the park, though not of the mountain. It was a chauvinistic characteristic of our nation to attach political names, quite often insignificant in history, to the glorious features of our land: Presidents, senators, governors, prospectors, sheepherders, and a few scientists are represented in the highlands, lowlands, deserts, and shores of our fifty states. Native American designations are in the minority on our maps. The fact that this is the highest peak in North America (20,600 feet) is a statistic with which the Original Inhabitants were not concerned, but the impressive presence of the mountain undoubtedly evoked a deep religious response.

This photograph of the north slope of the mountain was made at about 1:30 in the morning (the sun set at about 11:30 the night before). Here in July there is always light at midnight — a calm dusk of silence and wildness. Although not far south of the Arctic Circle, the days are agreeably warm, even hot, and the mosquitoes enjoy themselves twenty-four hours a day, for as long as warm weather holds and the epidermis of man and beast is available!

I was on a Guggenheim Fellowship trip, and the National Park Service, on order of the Director, generously provided transportation from McKinley Station to the ranger cabin at Wonder Lake. This site overlooks a vast valley to the south, beyond which rises, many miles away, the glittering mass of McKinley — eighteen thousand feet of ice and snow soaring above its base. I spent nearly a week there with only two cloudless days, and I saw many beautiful areas. On the afternoon of my arrival at Wonder Lake I had been able to get a photograph of the mountain wreathed in cloud with the moon hovering beside it. It was a startling experience for a "southerner" to see the moon so low in the south and actually passing *behind* the mountain on its westward journey.

That evening, with a premonition of success ahead, I had an early supper and pulled

down the shades to create night in the cabin. The mosquitoes did not sleep, but a netting was draped over the cot, which kept most of them away. I was up and out at midnight and made a photograph of the stark white ghost of the mountain under the gray light of the sky. I then prepared for sunrise, due in less than half an hour. Actively opposing the mosquitoes, I set up the camera and composed the image on my 8×10 groundglass.

About 1:30 A.M. the top of the mountain turned pink; then, gradually, the entire sky became golden and the mountain received more sunlight. I determined that the 23-inch component of my Cooke Series XV lens was appropriate, but I was perplexed as to the right filter to use. While the foreground, lake, and distant valley were in shade, the light was very soft, and I wanted to sharpen what shadows there were on the mountain. With Isopan film at ASA 64, I had anticipated using a Wratten No. 8 (K2) filter, but as the scene developed before me I first thought of a red filter (Wratten No. 25A) but settled on the deep yellow Wratten No. 15 (G) with a factor of 3.[1] I was frankly confused by the yellow color of the

sky, undoubtedly caused by the early sun on water vapor waiting to become clouds.

The No. 15 filter was satisfactory in lowering the values of the shadowed foreground, but the separation of mountain and sky was not as I had hoped. I placed the deepest shadows on Zone II½ (the filter lowered them to Zones I½–II), and the sunlit snows of the mountain fell on Zone VI,[2] which the filter raised to about VII. Normal-plus-one development was appropriate. I do not know what else I could have done under the light and color conditions. One solution might have been to apply no exposure factor for the No. 15 filter and develop Normal-plus-two. Since filters pass light of their own color freely, I could have omitted the filter factor in this case to maintain the yellow-gold sunrise light on the mountain; with no factor the shadow areas would have been lowered in value. I tried two more photographs, but within thirty minutes clouds had gathered and obscured the summit, and they soon enveloped the entire mountain.

Unfortunately when I was later in Glacier Bay National Monument (southeast Alaska) I was unloading my gear from a

float plane to a small launch and the case containing all the exposed film of the trip fell into the shallow water. I jumped in up to my waist and quickly retrieved the case, but some water had penetrated it and damaged some of my 8×10 Mt. McKinley negatives — fortunately not this one. I laid the boxes of film out to dry on the rocky shore; I could do nothing more at the time. My next stop was the Juneau airport, where I almost missed the plane for Seattle and home. I did not know the extent of the damage until the film was developed in San Francisco. I lost some fine images from the water that seeped into the boxes at the bottom of the case. I learned the hard way about the importance of waterproof cases and containers.

Other things I learned on this excursion to Alaska: tundra is soft and wet; you cannot place an ordinary case on the ground. All cases should have sealed lids; dropping them in the bay is an uncommon occurrence but rain is not, and the effects of dampness are to be avoided both for equipment and negative material. Mosquitoes are a real threat; in reversing the back of my view camera I have trapped them in the

bellows and they came to rest on the film, appearing as silhouettes of airplanes in the skies of some negatives! As for their effect on humans, we must be grateful that the Alaskan mosquitoes do not carry disease, or that state would be uninhabitable!

I am convinced, after only two visits to "The Great Land," that Alaska is one of the most impressive reservoirs of beauty and wildness — an inexhaustable resource for creative interpretation. The Alaskan scene has been but lightly explored by the serious artists in all media.

1. Book 2, Chapter 5.

2. Book 2, pp. 57–59.

Tenaya Creek, Dogwood, Rain

Yosemite National Park, 1948

I have known very few days in Yosemite and the High Sierra that were definitely unpleasant. I have experienced occasional summer scorchers and a few dull, clammy days in late fall when the oaks are bare, the skies gray, the waters running low, and the land crying for rain or snow. Spring — the time of roaring waterfalls and dogwood blossoms — is often graced with showers; it is a time for enjoyment of varied subtleties of the natural scene, which are sometimes elusive and difficult to photograph.

One cloudy spring day I was searching for dogwood displays, and as I was driving up the Mirror Lake Road I glimpsed an attractive possibility near Tenaya Creek. I parked the car and walked about six hundred feet toward the dogwood I saw glimmering in the forest. On reaching the creek I saw an inevitable opportunity; I returned to my car and gathered my 8×10 equipment.

A light rain began to fall, and I considered giving up for the day, but when I came to an opening in the trees and saw this subject open up before me I banished such thoughts of defeat and set up the camera under protection of the focusing cloth. The

rain added a certain richness to the scene and suggested an atmospheric recession of values that would not otherwise be seen. It was fortunate that there was no wind, since the exposure was about $\frac{1}{2}$ second, creating a slight blur in the water but showing no movement in the leaves and blossoms.

Contrary to general opinion, the dogwood "blossom" is not the true flower, but modified leaves known as *bracts*. In the center of the "blossom" is the compact group of many flowers that turn to red berries in the late fall. In sunlight the glossy green leaves have a high specular value that competes visually with the white bracts. The distinction of these green and white values is clear only in shade. Viewing the dogwood tree through a polarizer[1] in sunlight will confirm this fact. The reflections of the leaves — those at the appropriate polarizing angle — are reduced in value, and the blossoms appear brighter to the eye and to the film.

As with many of my photographs, this picture opportunity seemed to be waiting for me; the visualization was immediate and complete. I hope that the print conveys not only the moment but some evidence of

my perception to which the viewer may respond. Just what this expressive perception contains must be sought for only in the print. I repeat my conviction that photographs alone can express the experiences of photography. We can describe and explain the physical elements of the scene, the forest, rain, white blossoms, the flowing stream and the lichened rock; but to try to express the photographer's emotional-aesthetic response might cause confusion for viewers and limit their response.

The technical problems were apparent from the moment I set up the camera. In black-and-white photography the dominant problem is usually holding a subtle spectrum of grays. Striving for contrast can result in sooty shadows and chalky high values that defeat the desired impression of luminosity. There is a logical and expressive balance point of contrast that is often very difficult to achieve. In this case the exposure and development decisions were relatively simple, but the final print posed problems. The subtle dry-down effect[2] can cause a serious loss of luminous quality, and careful printing for the high values is therefore necessary. In addition, the appro-

priate tone may not be attainable with certain papers. Many years ago I made a print of this negative on a contact paper that, when fully toned in selenium,[3] had a marvelous color. It is one of the most satisfactory prints I have ever made, and I have not been able to duplicate it with contemporary enlarging papers. The paper I used might have been Agfa Convira or Kodak Azo. Both were coated with silver-chloride emulsions, which tone faster and give more color than the predominant bromide or chloro-bromide emulsions of today.

The photographer learns to seek the essential qualities of his environment, wherever he might be. By this I mean that he should be tuned to respond to every situation. It is not enough to like or dislike; he must make an effort to understand what he is experiencing. To some, this location by Tenaya Creek on a rainy day might be merely damp and uncomfortable, and thoughts of returning to warmth and shelter would be enticing. To others, the cool calm rain and the forest light would be things to revel in, likely to initiate some creative reaction. My life is full of memories of experiences that are of greater im-

portance to me than the mere recollection of things and happenings. Unless I had reacted to the mood of this place with some intensity of feeling, I would have found it a difficult and shallow undertaking to attempt a photograph.

1. Book 2, pp. 113–115.

2. Book 3, pp. 82–84.

3. Book 3, pp. 130–134.

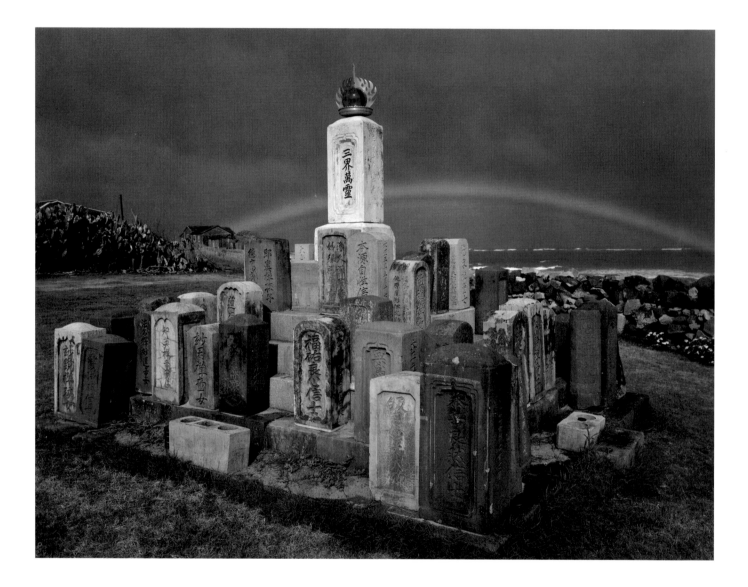

Buddhist Grave Markers and Rainbow

Paia, Maui, Hawaii, c. 1956

On a photographic assignment for the First National Bank of Hawaii, I was exploring for images that would interpret certain aspects of the Hawaiian Islands not usually covered by the average promotion photographs. In Paia, Maui, I had observed this rather beautiful gathering of oriental grave markers and began working out compositions of sections of the subject. The handsomely carved stones were of subtle values and textures. At first I was using a 121mm lens on the 4×5-inch view camera and was considering an image of strong convergence and depth-of-field effects. I also thought of working close to the inscriptions on the weathered stone.

I noted the first appearance of the distant rainbow, and my visualization quickly moved on to an ensemble of rainbow and stones. I changed to a 90mm wide-angle lens, which permitted me to encompass the entire arch of the bow and also have ample depth of field[1] to include the near stones and the distant line of the ocean. I was concerned that the rainbow might fade while I was struggling to find the best camera position, but fortunately, it actually grew in intensity while I worked. The sky was quite dark with cloud. I used a Wratten K1 (No. 6) filter to clear distant haze; a stronger yellow filter might have reduced the width of the rainbow by weakening the blue-violet bands.[2] Within a minute after making a duplicate negative (which had a defect!) it began to rain, terminating further photography in the area. The negative, on Kodak Plus-X filmpack film, was developed normally. The print was made on Seagull Grade 2, with a small amount of burning-in, and toned in selenium.

It is difficult to describe the steps of the creative process, especially with a subject such as this where there is a variety of restrictive elements. There is, to begin with, the appeal of the subject itself. Inscriptions in a foreign language can have a direct aesthetic quality, unmodified by the imposition of meaning. I am glad that I do not understand the language of most operas; I can enjoy the music without being bothered with the words, which are usually banal. I assume that this subject might have different significance to a Japanese person, because of the meaning of the inscribed characters on the stones. I observed the stones and the dark sky, and I considered an image which, for me, seemed appropriate.

I visualized the image very much as it appears here. In scanning the subject in relation to the visualization, the eye seeks

relationships and combinations of shapes that seem to agree with some basic concept in eye and mind. Positioning of the camera required a little care; not only the horizontal position and distance from the stones, but the height of the camera above ground, were important for the desired effect. The relationship of the stones, the dwellings, the distant surf, and the rainbow was a rather complex problem of what I define as image management.[3]

I suggest that you examine this photograph with a critical eye for camera point-of-view. I placed the camera at what I considered to be the optimum position; you can try to imagine the aspect of the subject and the relationships of shapes if the camera were moved. Only a few inches displacement in any direction — up or down, left or right, closer to or farther from the subject — will change the subtle separations of the stones and their relationship to the distant dwellings and the sea. For example, if the camera were raised a foot or so, some of the stones would be below the horizon line, and the effective isolation of the central white stone against the sky would be reduced. Allow the eye to rove and experiment; I had to make many rapid

adjustments in composing the picture. There is a moment of "intuitive rightness" that clears the way for release of the shutter, but I often examine my photographs later to explore the possibilities of improvement in visualization and craft.

While constructing form out of complex shapes, I also was considering the values and their placements on the exposure scale. With the Exposure Formula[4] in mind, the actual shutter speed can be quickly determined with the lens stop required for the desired optical image. The creative process represents a combination of the intuitive and the logical and, if the photographer is in practice, can occur swiftly and decisively.

I have tried to understand why Hawaii in its entirety did not excite me more than it did. It is undoubtedly a beautiful and unique part of the world, but it seldom stirred me creatively as did Alaska or the Sierra Nevada. The term semitropical usually signifies softness and lassitude to me, but on Molokai I experienced a frightening storm more severe than any other I have known. Clouds seldom performed well for me there. The black lava rock is as shapeless as granite is sculptural. I found the hu-

midity depressing. At high elevations the air is clear and invigorating, the vistas are vast, but I found a tiring sameness in the volcanic rock, the lush forest, and the surrounding sea. Real and human termites abound. The hot sun does not refresh me as it does in the desert. In other words, I found it difficult to visualize photographs except on a few grateful occasions. My five trips to Hawaii were functional in the sense that I was fully engaged with projects. If I were to return I would seek close details of shore and forest rather than wide vistas. I would hope for storms simply to give vitality to the generally bland situations.

1. Book 1, pp. 48–50.

2. Book 2, p. 99.

3. Book 1, Chapter 7.

4. Book 2, pp. 66–67.

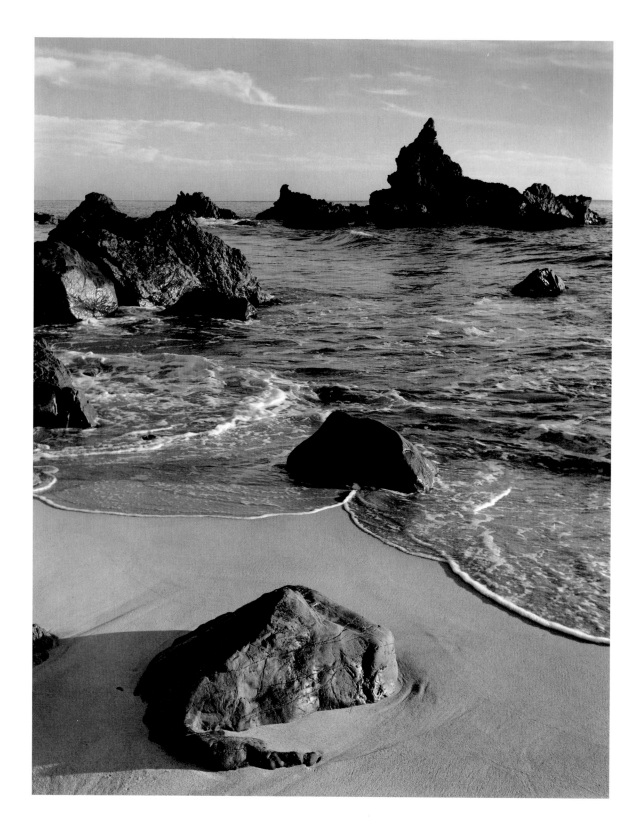

Rock and Surf

Big Sur Coast, California, c. 1951

Over the years I made numerous trips with William E. Colby, a great mining lawyer, conservationist, leader of the Sierra Club for many decades, and one of the strongest figures in the California State Parks movement. He loved the Big Sur Coast and built an attractive home at Coastlands, a small gathering of dwellings south of Pfeiffer–Big Sur State Park. One Friday at his request I picked up from his art dealer's warehouse in San Francisco a station wagon load of his newly acquired Chinese objects of art and furniture which, on a planned weekend excursion, we were to drive to Big Sur. A heavy stone figure was eased into the car along with some teak chairs and a small table. On the car camera platform a number of heavy teak timbers were lashed. All this freight, together with Colby and me, cameras, suitcases, and supplies, grossly overweighted the station wagon; the tires had that disturbing flat-on-the-bottom look that often bodes ill, especially for a lengthy trip through unpopulated rural areas.

We proceeded at a stately pace over the more than one hundred and fifty miles to our destination. The car leaned ponderously on the curves, the springs bottomed out frequently, and the brakes took their time when I had to slow or stop. It was a long and trying drive, but we arrived without incident. Colby's neighbors gathered and helped us unload the precious cargo while a strong fog-laden wind was blowing, and we longed for the coming cozy evening by a driftwood fire. Colby, a man of extraordinary determination and energy, made the usual ambitious plans for the next day.

We were up at dawn and started early on the steep trail that dropped about seven hundred feet to the shore. I carried my 4×5 view camera and accessories in my knapsack, my tripod in one hand and an axe in the other. Colby insisted on doing some work on the trail as we descended; he carried a pickaxe and shovel and the lunches as well. We encountered and attended to a few slides, washouts, and fallen shrubs, putting the tools to strenuous use. Arriving at the beach about noon, we explored a little to the north, finally stopped by cliffs rising from the high-tide surf. We had lunch: sandwiches, chocolate, raisins, a banana and some hard candies, but we had forgotten to bring anything to drink and the lunch exacerbated our thirst.

We explored a distance southward and I made several pictures of an exciting rugged

fraction of the coast; the best is reproduced here. I do not recall what view camera or lens I used, but it could have been a Deardorff camera I was trying out. I did not keep the Deardorff; it was a beautifully made instrument, but the adjustments were not adequate for me. The lens was probably my 145mm Zeiss Protar.

I am well aware of a compelling impulse of photographers to discuss, with collector's dedication, the equipment and materials they and their colleagues use, down to the smallest detail. I have never known painters to debate with such intensity the kind of canvas, paper, brushes, and paints used in their creative work. With photographers, however, such knowledge is traded in a kind of inner language of arcane significance. More meaningful would be discussion of such matters as the shapes, luminance values, and colors of the subjects. To know that an exposure was, say, $\frac{1}{8}$ second at f/32 has small meaning unless subject luminances, their placements on the exposure scale of the negative, and negative development are also indicated. Many readers avidly dwell on technical details; I find myself wondering at times just how Edward Weston made some of his photographs (he

talked little of means and methods — it was mostly empirical magic to him). I am not averse to giving procedural details if I think they have significance, since I know many photographers find them helpful.

It was rather late in the day when this exposure was made. The sky was slightly hazy and the clouds not too distinct. With Isopan film at ASA 64, I used a Wratten No. 12 (minus-blue) filter. I placed the exposure fairly low on the scale and gave Normal-plus-one development.[1] The filter darkened the rock shadows more than I had anticipated;[2] note the slight difference in value between the shadow of the near rock on the sand and the shadowed face of the rock itself. The very dark central rock fell on or below Zone I and had no effective density. The highest textured value of the scene fell on Zone VII. The edges of foam are accented by the low sun, and the shutter speed was sufficiently short to arrest their movement, and thus hold some texture in their ebb and flow.

Surf is seldom predictable (see page 22); in its ebb and flow it constantly presents fresh shapes, and the eye must be swift and anticipation keen to expose at the most favorable moment for the particular compo-

sition consistent with the visualization. The shapes and "movement" of the rocks seemed to await the appropriate configuration of the surf. Many waves broke on the sand and curled around the rocks before the one I photographed. The impulse to operate the shutter came at the appropriate fraction of a second before the foam curves met as we see them in the image. Anticipation is a very important part of the photographer's training, and is acquired only by much practice.

1. Book 2, pp. 71–79.

2. Book 2, p. 106.

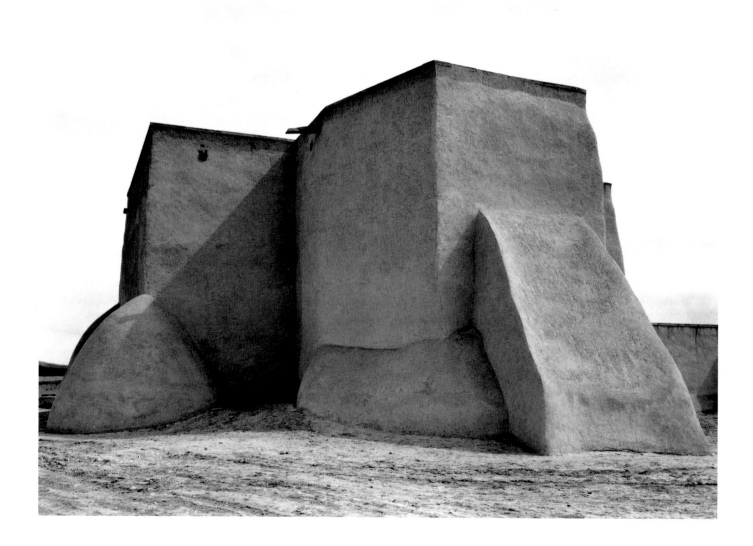

Saint Francis Church

Ranchos de Taos, New Mexico, c. 1929

This image is included in the twelve original prints in my book *Taos Pueblo,* published in 1930 and republished in facsimile form in 1977.[1] The church is not actually in the Pueblo, but in the little Mexican-American settlement of Ranchos de Taos a few miles south. Even so, Mary Austin, who wrote the text for the book, felt that inclusion of this photograph was justified because of the church's significance for the entire area. It was constructed in 1776.

I had not seen a photograph of the Ranchos de Taos church and had no idea of its magnificent form before I first viewed it (but did not photograph it) in 1927. The front aspects of the church are moderately impressive: two stalwart towers and a nineteenth-century gothic entrance arch, plus a desolate little cemetery plot in an enclosure of low wall, all of rigorous and simple design and structure. It is the rear elevation that defines this building as one of the great architectural monuments of America. It had been interpreted by numerous painters and photographers, and I could not resist the challenge. The building is not really large, but it appears immense. The forms are fully functional; the massive rear

buttress and the secondary buttress to the left are organically related to the basic masses of adobe, and all together seem an outcropping of the earth rather than merely an object constructed upon it.

I made few photographs of consequence in New Mexico in 1927, as my first trip was rather brief. In 1928 and 1929 I was using my $6\frac{1}{2} \times 8\frac{1}{2}$ Korona View camera and the same $8\frac{1}{2}$-inch Tessar-type lens I used to make *Monolith, The Face of Half Dome* (see page 2). During these early years much of my work was done with orthochromatic film (sensitive only to blue and green light).[2] This picture was made in mid-afternoon with no filter. Hence the blue sky was rendered quite light and the shadows were softened. I was fortunate with the exposure; I was not yet familiar with the high-altitude light of the Southwest, and I overexposed many pictures in those early years.

This image is an experience in light. I sensed the quality of light at the time but could not directly relate it to the photograph. Some intuitive thrust made this picture possible. I had used yellow filters (and red filters with panchromatic film) for many images in the area, but on this one

occasion some gentle angel whispered "no filter" and I obeyed. A darker sky would have depreciated the feeling of light. A more contrasty print also would have destroyed the inherent luminosity of the subject.

The prints for the *Taos Pueblo* book were made on a special Dassonville paper. We started with a mildly textured rag paper of highest quality produced especially for this project in New England. Half the paper was sent to the Grabhorn Press for the text pages, and the other half to Will Dassonville for coating as the photographic paper on which I made the prints. It was of highest quality and yielded rich deep values, especially with Amidol developer.

Will Dassonville was an excellent photographer. He was considered a Pictorialist, but he did not often express the pictorial intentions of his time. He made many fine photographs which deserve more attention than they have received. In his later years he turned to manufacturing a photographic paper that was very successful until the smooth, glossy papers took over the market. After the Pictorial emphasis faded, Will was obliged to close shop — a regret-

table loss — and I have never found a paper that had the particular qualities of Dassonville Charcoal Black. He recommended Amidol as the developing agent and the tried-and-true stop bath and fixer formulas, and he advocated *thorough* washing.

In the main, the twelve original prints on Charcoal Black bound into the *Taos Pueblo* book have lasted well. I knew nothing of selenium toning in those days; since the Dassonville emulsion was simple silver bromide it might not have toned in selenium to any degree of color. Toning would have enhanced its permanence, but in those days we were not aware of archival procedures. Countless formulas, many based on bathtub chemistry, and arcane procedures flourished, and a few were effective; but in retrospect, many of the procedures of the time had about as much validity as alchemy. However, very beautiful (and fortunately permanent) prints were made in all periods of the art. And, as in our time, many bad ones were produced, and most but not all of these are forgotten or remain as mere curiosities.

What mechanism of the eye and mind selects patterns and relationships in an

unfamiliar world about us and composes them as expressive images? I can remember making this photograph; with the parameters of the film size and the focal length of the lens set in my subconscious, I seemed to know precisely the square yard of earth on which to place my tripod. There was no hesitation in this, and no change of position; the image appeared on the ground-glass in almost ideal placement. Only a slight leveling of the camera and raising the lens about one inch were needed to complete the composition. We should never deny the power of intuition or hesitate to follow its revelations. I have found that when I have to labor over a composition I seldom achieve anything worthwhile. I except, of course, the minute refinements of distance and position, and the essential adjustments of image management.[3]

It seems as if the mind is constantly churning facts, moments, relationships, and concepts, and reverberating to the input of information and the flowering of emotion. It is essential that the artist trust the mechanisms of both intellect and creative vision. The conscious introspective critical attitude has no place in the luminous moments of creative expression, but should be reserved for later, when the work is complete.

1. New York Graphic Society Books, Boston.

2. Book 2, pp. 21–25.

3. Book 1, Chapter 7.

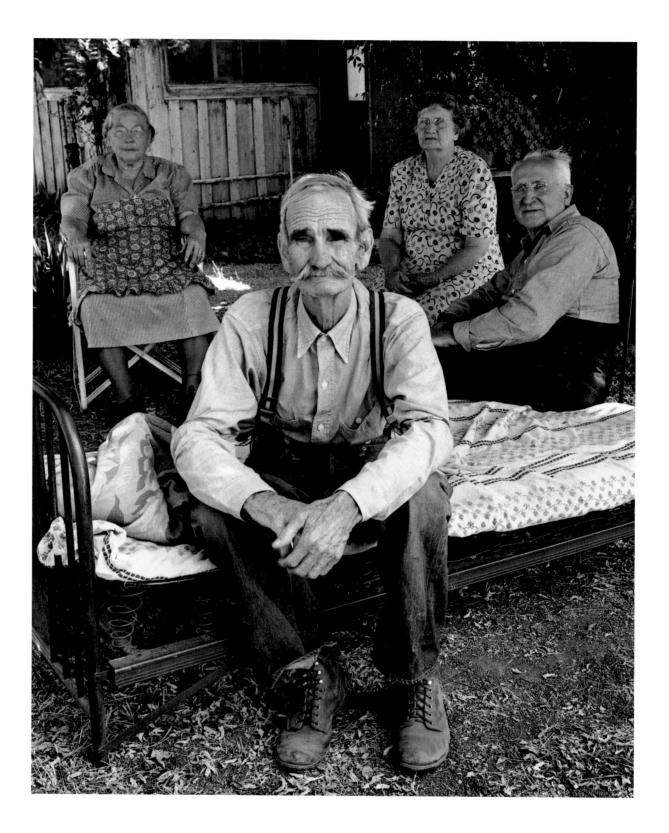

Farm Family

Melones, California, c. 1953

I well recall this blistering hot day in the Sierra Nevada foothills east of Modesto. I was on a photographic trip for the American Trust Company (now the Wells Fargo Bank) of San Francisco. The project was a series of photographs made in areas served by the bank, which were to be reproduced in a brochure as part of the bank's promotion program. Nancy Newhall was engaged to do the text. The bank was astonishingly flexible: "Do your own interpretive stuff" was the basic instruction. It did require considerable research to plan the text and images for the bank's approval, through their agency, the J. Walter Thompson Company. I commend the American Trust Company for their appreciative attitude toward this project; it is seldom that a professional photographer is given such freedom and cooperation. It was the kind of project we all dream about but rarely encounter! The project was published in 1954 as a book, *The Pageant of History in Northern California* (not our recommended title!).

As I have often said, professional work depends upon "assignments from without" and personal creative work stems from "assignments from within." Quite often the first situation stimulates the second, with impressive results. In this case, the project represented a blend of the two; I was required to cover a number of general themes but had interpretive freedom with each. I find often that once I have a reasonably clear idea of a project I do not search specifically for subject matter. I prefer to keep moving through an area until I happen upon a situation that I recognize as relating to the project. If my intuition is strong I can roughly but quickly project the desired images in my mind. But sometimes nothing happens for days (if then), and I have often broken off a quest to gather fresh inspiration. Of course, there are professional assignments that will not await the whims of the photographer or the weather or the subject itself. "Get it or else" is a client attitude recognized by all professionals. I usually could get the image under difficult conditions, but in many such cases it was not a resounding creative success!

This hot day was typical of the region in mid-summer: 100°F in the shade, dust, dry strawlike grass, and persistent smoky haze veiling the distant vistas. I was cruising in the country west of Highway 49, exploring the area in search of a typical farm and farming family. I traced many suggested

places and names, but few had the desired qualities. I was looking for an environmental situation and a family that represented small farming in that area, not the corporate or the sometimes ostentatious estate farms, nor the obviously run-down farms that are associated with the dust-bowl experience of the 1930s.

I came across a modest cluster of farm buildings set in a hollow of hot rolling hills. The remnants of a creek trickled by some oaks, and a few cattle could be seen on the horizon (many had been moved to higher pasture or to feedlots on their way to the inevitable climax of steer life). The inhabitants, members of the Whittle family, were very cordial: "Let's go sit out back and you tell us what you want."

Under the combined shade of a tree and a large sail of canvas were chairs and cots on which the group lounged out the fierce afternoon heat. We talked about the farm, the cattle, the dry winter past, and other topics of the rural scene. I had my 4×5-inch camera set up, and I suddenly saw the composition and proceeded to make the photograph. I used a 5-inch Ross Wide Angle lens and Kodak Plus-X filmpack, developed

Normal-minus-one in Kodak D-23.[1] I recall the exposure was $1/5$ second at f/32.

The photograph was not posed in the usual meaning of the term. The subjects were all sitting as we see them. I explained that they should not try to pose but just relax and look at the lens while we were talking. I had to move the camera into optimum position to avoid mergings of the heads with background shapes and values. With the relatively short-focus lens I was able to stress the scale of the foreground man moderately and enhance the impression of depth in the image. I needed a high viewpoint. I pointed the camera down slightly, as no convergence problems were involved, and adjusted focus with the tilting front.[2]

I instinctively felt that my first exposure gave me the picture I wanted; I made several others of the group and of the individuals, but none was as convincing. The first-person effect, with the subjects looking directly at the lens, was especially rewarding in this case.

The subjects were placidly enduring the heat while I was steaming from my activity. At the end I was rewarded with cold

beer and potato chips, and I returned to my motel (and more beer) in the still heated summer dusk.

On reviewing this photograph I thought of what I would have to do under a different professional assignment, working with models or with conscripted locals. Contriving a situation is very different from analyzing actuality. If a composition of this character is "too perfect," I am convinced the viewer recognizes its artificiality. The majority of advertisements have, for me, this unreal quality which I find difficult to trust. The clothes are too clean or too theatrically mussed, the models too slick, the environment too manipulated. I feel free to speak on this as I have been obliged to make many pictures involving contrivance and exaggeration. Working with the Melones farm people nearly thirty years ago was indeed a refreshing experience.

1. Book 2, pp. 71–79.

2. Book 1, pp. 149–154.

Silverton

Colorado, 1951

I was traveling with friends between Durango and Ouray, on a trip through the San Juan Range, and found myself roving around Silverton with a camera. I saw no architecture of any importance compared to that of other old Western towns, but there seemed to be a special patina, enhanced by the high-altitude light and the static dignity of the place, that was irresistible. I passed this subject possibility several times in the morning without any photographic excitement, but early in the afternoon I saw it as a rather astonishing revelation of shapes that I quickly visualized as the image reproduced here.

The vigorous geometric configurations of the buildings and the mountain fell into place with small effort on my part. The optimum camera position was obvious from the start, and I was fortunate in having a 10-inch Kodak Ektar wide-field lens for my 8×10. The 12-inch Dagor encompassed a too-narrow angle of view; moving the camera back to accommodate this lens spoiled the perspective energy of the composition.

The subject was of obviously strong contrast. The deepest shadow of the fence fell about on Zone II. I used a No. 12 yellow filter to clear the slight haze. Normal-minus-one development in Edwal FG7 gave a good range of densities on the negative, which prints best on a paper such as Oriental Seagull Grade 2. The print is not easy to make; a balance between luminance and brilliance is required. Toning has much to do with the end effect. This image is especially effective in 16×20-inch size. It tolerates detailed visual exploration, and I have used it with students to discover many possible images considering the effects of different viewpoints or of lenses of different focal length.

It is a good exercise to imagine yourself at the position of the camera before this subject. Moving closer with the same lens would reduce the area of the buildings included on the film and increase their apparent size, while the mountain is relatively unchanged in size because of its greater distance. Thus the scale of the buildings in relation to the mountain is increased. Moving farther away has the opposite effect: the structures become smaller in relation to the mountain. We are sometimes transfixed by the appearance of a subject from a given point of view, and explore only the effects of moving the camera up or down, or sideways. We should also experiment

with moving closer or farther from the subject, and note the differences of scale and shape relationships thereby produced. This three-dimensional change of viewpoint is essential to the concept of image management and clarifies an important principle: The *perspective* of an image is controlled by the *distance* of the lens from the subject; changing the focal-length of the lens changes the *size* of the image, but does not alter the perspective.[1] Many photographers overlook this fact, or are unaware of its significance.

In the usually organic shapes of nature, the element of perspective is not a problem as it is with more recognizable forms, such as geometric shapes or faces, for example. We can achieve an exceptionally strong perspective effect with a short-focus (wide angle) lens by moving very close to our subject. The change in true perspective results from moving toward the subject, rather than being a property of the wide-angle lens itself. Such optical exaggerations of subjects can be carried to a degree where they are obviously a distortion of reality. We may find a face subjected to such distortion very disturbing. Or we may be able to at-

tain aesthetically and emotionally exciting effects that have small relation to the "realistic" aspects of the subject.

When I was working with Dorothea Lange in 1953 on *Three Mormon Towns,* the people could not understand why I photographed old structures. I was advised, "There is a new barn over there; it would make a fine picture. This one won't last much longer." It was difficult to explain, even to myself! *Why* do I almost consistently avoid new construction? I do not photograph things simply because of their historic, architectural, or curiosity value. I also do not consciously relate the old homes and barns to the past humanity that conceived and built them. I do not think I have nostalgic overtones in my work — although people may develop nostalgia when viewing it. I do not think I would enjoy living in earlier times — I am a "future" person. I do not impose documentary comment on my subjects.

Why, then, do I seem to delight in old structures such as homes, barns, mining-town buildings, New England relics, long-past evidences of man in the American Southwest and in the very few places I have

visited in France and England? It is not escapism for me. I can only say that I photograph what appears aesthetically beautiful and what I can visualize as a photograph worth creating, for myself and, I hope, for others.

1. Book 1, pp. 97–100.

Clearing Winter Storm
Yosemite National Park, 1940

Yosemite was home for many years for Virginia and me and our two children. We moved there in 1937 and took over management of the studio founded by Virginia's father, artist Harry C. Best, in 1901. Around 1947 we re-established our home in San Francisco as I had need for a professional studio; I could not legally conduct my professional work in a National Park.

While living in Yosemite I had great opportunity to follow the light and the storms, hoping always to encounter exciting situations. There were hundreds of spectacular weather events over the years, but the opportunities to photograph them were limited by the accidents of time and place, especially when working with 8×10 and 4×5 view cameras.

Weather, however spectacular to the eye, may present difficult conditions and compositions, especially when working with large cameras. Setting up the camera takes several minutes during which the first-promising aspects of light and cloud may disappear. I would sometimes wait hopefully for the scene that I could visualize as an exciting image. It was occasionally realized, but I have always been mindful of Edward Weston's remark, "If I wait for something here I may lose something better over there." I have found that keeping on the move is generally more rewarding. However, it is important to say that I photographed from this particular viewpoint in Yosemite many times over many years, with widely varying results.

Clearing Winter Storm came about on an early December day. The storm was first of heavy rain, which turned to snow and began to clear about noon. I drove to the place known as New Inspiration Point, which commands a marvelous vista of Yosemite Valley. I set up my 8×10 camera with my 12¼-inch Cooke Series XV lens and made the essential side and bottom compositional decisions. I first related the trees to the background mountains as well as to the possible camera positions allowed, and I waited for the clouds to form within the top areas of the image. Rapidly changing situations such as this one can create decision problems for the photographer. A moment of beauty is revealed and photographed; clouds, snow, or rain then obscure the scene, only to clear in a different way with another inviting prospect. There is no way to anticipate these occurrences.

At this location one cannot move more

than a hundred feet or so to the left without reaching the edge of the almost perpendicular cliffs above the Merced River. Moving the same distance to the right would interpose a screen of trees or require an impractical position on the road. Moving forward would invite disaster on a very steep slope falling to the east. Moving the camera backward would bring the esplanade and the protective rock wall into the field of view. Hence the camera position was determined, and the 12¼-inch Cooke lens was ideal for my visualized image.

I focused on the foreground trees, and at a moderate aperture the mountains were in focus. A fairly short exposure was required to avoid showing movement in the clouds. As I recall, an exposure of ⅕ second was given at f/16 with Isopan film (ASA 64) and a Wratten No. 8 (K2) filter. After focusing I wiped a few drops of rain off the lens and kept it covered with a lens cap until the moment of exposure.

An average reading of a scene such as this, with normal development, gives a low contrast negative. The clouds were gray, and what sunlit areas appeared were pale and had very soft shadows. I knew from experience that, with normal development of

such a negative, a Grade 4 paper would be necessary to approach the desired contrast. Although the scene was of low general contrast, my visualization of the final print was quite vigorous. The subject had a very dramatic potential. The image could not be simply contrasty; all the values required interpretation consistent with a deep, rich expression of substance and light. As I cannot define in words the emotional or aesthetic qualities involved in the making of any photograph, the reader is obliged to refer to the image itself. Visualization relates to the final image, not to words used in attempts to describe it. When I am making a photograph I do not entertain critical attitudes; analysis is helpful only after the picture is made.

With the picture clearly in my mind's eye, I measured the luminances of the subject. Before the days of spot meters I directly measured values within the 30° viewing angle of the meter or, as was the case here, I attached a tube before the meter cell, reducing its viewing angle to about 15° and, of course, requiring me to multiply by four the luminance value of any area measured by the meter. The highest textured value I could determine in the scene

was about 160 c/ft^2. Placing this on Zone VII, I found that the value of the darkest trees on the right (measuring about 3 c/ft^2) fell on Zone I. The average value of the forest, with its light dusting of snow, fell on Zones II and III. The brightest areas were in the clouds, excepting the waterfall in the shaft of sunlight; this I would estimate as being about 500 c/ft^2, and I knew it would show as a small white vertical shape in the final print.

I could have given two to four times the exposure to raise the value of the trees, but I would have probably lost a certain transparent feeling of light that I believe the print reveals. With this minimum exposure given the negative, the development instructions were Normal-plus-one.[1] This moved the high values (placed on Zone VII) to Zone VIII, and a general crispness of all the values resulted.

I used the Wratten No. 8 (K2) filter simply to remove the atmospheric haze inevitable with landscape subjects several miles or more distant.[2] I would have used a No. 6 (K1) filter had it been in my kit. I have always avoided using filters of greater strength than needed for specific effects.

The negative holds the information re-quired. It is a fairly strong negative, and looks like one that would be quite easy to print. It is not! Using a normal paper, such as Ilford Gallerie Grade 2, all the values are held at a fairly realistic level, which I did not desire. I tried Gallerie Grade 3 with Dektol developer, but I finally selected Oriental Seagull Grade 3 (giving about one-half grade more contrast than the Gallerie Grade 3) developed in Selectol-Soft plus 20 percent Dektol stock (500 cc Selectol-Soft stock, 1000 cc water, and 100 cc Dektol stock).[3] Subsequent toning in selenium improved the middle and low values.

A certain amount of dodging and burning[4] was required to achieve the tonal balance demanded by my visualization. I never retouch a negative, in the conventional meaning of the word, but I resort, as do all photographers I know, to dodging, burning, print-developer controls, and spotting. As I have described in *Book 3, The Print*, a negative properly exposed and developed in relation to the subject-luminance scale contains essential information for printing; I think of the negative as the "score," and the print as a "performance" of that score, which conveys the emotional and aesthetic ideas of the photographer at

the time of making the exposure. The print will usually require logical controls locally, since there is no such thing as the ideal or perfect negative. The negative is the conveying phase of the process, between the subject and the expressive print. My work is realistic only in reference to the image of the lens; values are modified as required for the visualized image. Such modifications are accomplished strictly within the limits of practical photographic techniques.

Although this photograph is often seen as an environmental statement, I do not recall that I ever intentionally made a photograph for environmentally significant purposes. My photographs that are considered to relate to these issues are images conceived for their intrinsic aesthetic and emotional qualities, whatever these may be. To attempt to make a photograph like this one as an assignment for an environmental project, for example, would be stimulating but quite uncertain of result. I have been at this location countless times over many years, but only once did I encounter just such a combination of visual elements.

I always encourage students to photograph everything they see and respond to emotionally. Intellectual and critical pre-evaluation of work is not helpful to creativity; regimenting perception into functional requirements is likewise restrictive. I have made thousands of photographs of the natural scene, but only those visualizations that were most intensely felt at the moment of exposure have survived the inevitable winnowing of time. Some images are useful historically or as aids to recollection of subject or event, but these certainly do not have the appeal or impact of the images that relate to external beauty and internal creative response.

1. Book 2, pp. 71–79.

2. Book 2, pp. 106–107.

3. Book 3, pp. 93–95; Book 3 contains a sequence illustrating my printing of this image, Figures 5–7 to 5–12.

4. Book 3, pp. 102–110.

Arches, North Court, Mission San Xavier del Bac

Tucson, Arizona, 1968

I have had intimate visual experience with Mission San Xavier del Bac, south of Tucson. In addition to many individual images I made, Nancy Newhall and I worked on an article on the mission that was presented in *Arizona Highways* in April, 1954 (vol. 30, no. 4). This appeared as a book, *Mission San Xavier del Bac,* published by Five Associates, Inc., in 1954. In the course of this project I made a considerable number of photographs, some of which I count among my best work.

The Franciscan monks were always kind and helpful to me, especially Father Celestine Chinn, who was imaginatively active in mission restoration programs. This mission is known as "The White Dove of the Desert," and for good reason. It is a large stone and adobe structure, the best example (I am told) of Mexican Baroque architecture in the United States. It has, of course, been extensively restored and repaired over the nearly three hundred years of its existence. It is painted a blazing white and is especially impressive against black thunder skies of summer. It serves as a Franciscan church and mission; the Papago Indians claim it as their own, as it is located within their reservation. It has a firm reality and presence, and does not seem affected by the hordes of tourists that are drawn to it as a historical shrine.

A subject like this is a creative expression of architecture and must be respected as such. It is easy to impose the pictorial insults of the picturesque upon it; in fact, it is sometimes difficult to avoid them unless the photographer really sees the subtle shapes of the building and its relationship to the land and the sky.

In my many camera explorations in and about the mission I was especially attracted by the handsome arcade of the north facade. The north face of the arches, always in shade, reveals exciting vistas of the east tower and the central dome. The finials of the adjacent wall create strong near-far relationships — and depth-of-field problems as well. I have many negatives of this portion of the mission, made with various cameras. The one I consider most successful was accomplished in 1968 with a 4×5 Arca-Swiss view camera and a 90mm Schneider Super Angulon lens, with a No. 12 (minus-blue) filter.

A precise camera position close to the arches was necessary to reveal the tower and dome beyond. At this position rather

full adjustments of the camera were required — more than the rising front alone would provide. The rising front was set at maximum, the camera tilted upward, and the back set at vertical position to assure geometric accuracy. The front was adjusted for all-over sharp focus.[1] The near wall finial on the left was brought into focus by a slight swing of the lens; the lens was therefore taxed to its limits of covering power.[2] The plane of focus[3] was approximately from just beyond the finial to the iron gate on the right.

This is an example of the need for careful positioning of the camera and lens to assure maximum clarity of the composition. Imagine what the effects might be at even slightly changed camera position: moving closer would enlarge the arches, or at least crowd them too severely in the negative format. Moving to the left even a few inches would have merged the cornice of the west tower with the central arch and confused the gate on the left with the edge of the finial base. Moving back would have diminished the effect of scale of the finial in relation to the more distant structure, and the arches would have partially obscured what we see of the main building.

Moving to the right would have shown a little more of the east tower wall and would also have revealed a distracting architectural detail on the shadowed wall beyond. Note that the curve of the dome is completely shown against the sky.

Careful exploration of the subject before making the exposure is of great importance. It is easy to casually scan the subject — even the groundglass image and the image in the camera finder — and overlook the small bothersome defects in the composition. The eye adjusts for the interruptions of one shape on another in the line of view, mergers of line and edge of objects differently placed in space, and objectionable edge intrusions that should be considered in the original visualization for the image format. Too often we discover small disturbing elements in printing that we did not see at the time of exposure. Occasionally they can be corrected, for example when small objects such as branches intrude at the edges; these can often be trimmed from the final print.

In many cases a small change in the camera position will eliminate such edge intrusions, but we must be careful not to accidentally create unfortunate mergers and

interruptions within the central areas of the image. There are also exasperating situations when, for example, there is a beautiful small form near the print border, but we find that some annoying intrusion appears at the same border and cannot be cropped off without damaging the important form. If the image permits, we can sometimes tilt it within the format to crop one element without the other, but this is usually inappropriate because of a level horizon or an obviously vertical shape.

I believe this photograph represents the best possible compositional arrangement under the conditions of subject and my equipment. Subjects such as this demand most careful exploration of every part of the image on the groundglass. Careful alignment of the camera is *very* important; with the short-focus lens and the degree of adjustments involved, small errors of alignment would create obvious distortion.[4]

The negative was made on Polaroid Type 55 Positive-Negative Land Film. I was working intensively with this material at the time; as a consultant for Polaroid, I was naturally interested in exploring its possibilities, and I enjoyed having the immedi-

ate image at hand. While I like to feel assurance that I can visualize the completed image, it is nevertheless rewarding to be able to see the print within moments and take advantage of the technical and expressive "feedback" that the Polaroid Land process offers. Exposing the positive-negative material correctly for the negative gives a weak "proof" print that nevertheless reveals optical and compositional qualities, and yields an excellent negative.[5]

If the advantages and limitations of the Polaroid Land process are well understood, visualization of the image prior to exposure can be as precise as with conventional materials. The negative has excellent grain structure and fine resolution; I have made 30×40-inch enlargements from this material with quite satisfactory results.

I made the first photograph without a cloud visible in the sky. I examined the results and found them acceptable, and I was about to take down the camera and move on when a completely unexpected cloud appeared beyond the dome. I was able to make another exposure with the results as shown. In the original enlargement the white cloud and the whiter dome are

clearly separated. I recall that the cloud luminance fell on Zone VII, and the most brilliant part of the dome was on VII½. The negative had an effective speed of 40 ASA; the exposure with the No. 12 filter was ⅛ second between f/11 and f/16. The first exposure (without the cloud) was ¼ second between f/16 and f/22, but I felt that the cloud might show motion and hence changed to a ⅛-second exposure. In retrospect I am always grateful for the benefits of prior intensive practice!

I had seen, appreciated, and worked with the subject several times in the past. But the qualities of the moment of perception were, of course, different from anything seen and visualized before. I also made a photograph on conventional film, changing only aperture and exposure time for the six-times increase of film speed (Kodak Tri-X at ASA 250). The scale of the Polaroid negative seems more appropriate for the subject; the grain certainly is superior.

It is not easy to print, as I must be certain to preserve maximum brightness of the whites; dry-down must be expected and tested for. Dry-down refers to the fact that the high values will appear brighter when the print is wet than after it has dried, sometimes much brighter, and this effect must be anticipated in printing.[6]

I could visualize an entirely different print from a conventional negative, wherein I would place the shadow values considerably higher and all values would be of rather high key. It could have been an effective image, but I like the dramatic effect achieved in the photograph reproduced here. I prefer the shadowed arches as deep as they appear in this print. The high values are also well represented; if they were blocked and lacking in substance, the impression of light would suffer. I could not have given more exposure to the Polaroid negative without destroying subtleties of the high values.

1. Book 1, Chapter 10.

2. Book 1, p. 54–55.

3. Book 1, p. 48–50.

4. Book 1, pp. 158–159.

5. *Polaroid Land Photography,* Chapter 4.

6. Book 3, pp. 82–84.

Still Life

San Francisco, California, c. 1932

This photograph was not made for any professional purpose; it was a simple arrangement of objects assembled and photographed with aesthetic intent. The data follows: Made with a 10-inch Goerz Dagor on Kodak 8×10 Commercial Panchromatic film developed in pyro. Illumination was direct light from a skylight plus light reflected from a 16×20-inch white card placed about six feet from the subject. I determined the balance of illumination visually. Three negatives were made, using 5-, 10-, and 15-second exposures (I knew nothing about the reciprocity effect[1]). I have forgotten what the lens stop was, but I recall that the 10-second exposure was the best.

As the years passed I had a better concept of the difference between the contrived (arranged) composition in the studio, which is a *synthetic* creation in that it involves putting together elements to make an agreeable arrangement; and a composition from the external world, created by an *analytic* process in that we select and manage the elements of the photograph in the existing surround. The studio arrangement is made with the idea of the photograph in mind, and the photographic process allows a further refinement of the visualized image. The photographer composes mostly outside the camera, then brings the camera into position and makes the exposure. Studio arrangements are also favorable to color photography, where the photographer may choose substances and objects of related color values and give them the most appropriate lighting. A convincing simulation of reality is extremely difficult in any studio set-up, and it is often better to follow the intuitive concept based frankly on contrived situations and lighting than intentionally to fake external conditions.

With black-and-white and color photography bizarre effects of lighting and compositon are, of course, possible. Conventional studio lighting can become boring and repetitive, and the careless application of artificial lighting is distressingly unconvincing. However, very rewarding effects are possible with *available* light in the studio, whether from natural skylight or window light, or from existing artificial sources. This photograph is a good example of available lighting from skylights and distant windows, helped by a reflector.

Arrangements like this one are achieved

both by actual construction of the subject and by refinements observed and managed on the groundglass of the camera. Making a close picture of this type convinces the photographer that there is a profound difference between what the eye sees and what the camera "sees." The nearer the subject is to the lens, the more important it is to evaluate it from a position very close to the lens, or —ideally — by composing directly on the groundglass or through a reflex finder. Adjustments of both subject arrangement and camera position were critical here to achieve the desired effect.

The camera was first placed opposite the center of the subject, but the image on the groundglass was four-square and stiff. I was viewing the subject from a point about 18 inches above the lens and, while I was not conscious of the need for some convergence, I instinctively raised the camera to eye-level position. I then pointed the camera down, gaining a small amount of convergence.[2] The image came to life with this relatively minor change of camera position. I thought of using the 19-inch rear element of my 10-inch Dagor and working at a greater distance, but this would have given a rather dull two-dimensional effect.[3]

For some viewers this photograph is just a collection of objects. Some others have said it gives pleasure because of the shapes and textural variety of the subject and the image values. The juxtaposition of the bottles, the egg-slicer, and the eggs may appear real or unreal to different viewers and modify their reactions to the image. For me, it remains a pleasant reminder of an aesthetic experience and, in its own way, is a worthwhile image.

The original fine print has a gratifying value scale. It shows the different surface qualities of the egg in its shell and the other egg without shell in the slicer. The specular reflections of the aluminum slicer are rendered pure white. The characteristic curve of the film used had a rather long straight-line section. I had no way of evaluating basic film properties in those days; we found out by experience that some films had "longer scale" than others, and some required shorter or longer development. As we became more proficient in our craft, we could anticipate effects of lighting and contrast and could make fair judgments on developing time, etc. Actually, we did not know just what was taking place physically and chemically, and much of our work was

fortuitous approximation refined by bracketing exposures and developing times. Through the years I have discarded all but what I thought were the best images.

It seems that Edward Weston and I photographed the same type of egg slicer unbeknown to each other. Both of us were accused of visual plagiarism, but we were merely amused at the coincidence. There are certain subjects that are photographed many times by many photographers in almost the same manner, since they are best seen only from certain points of view. Downright imitation is not to be condoned, but unconscious duplication of viewpoint and general effect cannot be avoided.

1. Book 2, pp. 41–42.

2. Book 1, pp. 143–146.

3. Book 1, pp. 97–100.

Jacques Henri Lartigue

Arles, France, 1974

My visit to Arles in 1974 was my first European experience. As usual when I visit places for the first time, I went with some vague (but usually confirmed) notions mostly derived from observing photographs, reading texts or letters, or hearing the opinions of friends. I anticipated favorable reactions to New England, New York, the Northwest, Alaska, and New Mexico, as well as England and Scotland. All proved exciting to me. On the other hand, I did not have favorable projections of Hawaii, the American South, and Europe in general. Here again my expectations were supported by my later experience. Wherever I have gone I have had high hopes even when my anticipations were not always positive. I must bear in mind that my reactions were limited to my particular local experiences, small parts of the potential whole. All such reactions are basically subjective and have profound effect upon what is observed and visualized. It is by no means uncommon to suffer periods of creative emptiness even in areas that are most attractive and exciting.

I went to Arles to attend, at the invitation of Lucien Clergue, the photography workshop of the annual Arles Festival of the Arts. The trip from Paris to Auvergne was a darting but smooth train ride on the *Mistral*, which was a great transportation and gustatory experience. I was lightly charmed by the swift-passing landscape but bored by its rural sameness and the evidence of tired antiquity and modern industrial landscapes. At Arles the people were wonderful and the food magnificent, but the place was very hot and crowded. I confess to acute homesickness; the Carmel Highlands coast and the cool Pacific sea fogs beckoned most of the time.

One day during the festival the photographic group visited the Camargue — a desolate hot plain near the coast noted for its cattle ranches. I found it despairingly drab and photographically uninviting. Fortunately, the catered lunch was marvelous. I do not know what anybody accomplished at this desolate session under the hot gray sky except to talk, consume good wine and food, and make insistent attacks on each other with 35mm cameras. The heat was comparable to that of the San Joaquin Delta country in California, where it is often 100°F and more in the shade. But everyone was having a happy experience, and seriousness was cast upon the steaming air.

Jacques Henri Lartigue — a magnificent

gentleman on all counts — was with us, and as he spoke English very well we got along splendidly. He had visited us in Carmel several years before the Arles experience. I have no French, nor any other language but American English, so communication with the group was somewhat restricted, although I was surprised how many Europeans did speak English. Lartigue is strikingly handsome, and I was able to make several negatives of him that pleased me very much.

Lartigue comes from a well-to-do French family devoted to the good life, activities and social gatherings richly documented in the early 1900s by his questing camera. He is an excellent painter and a unique photographer. His work and mine are vastly different in almost every way, yet I feel a warm empathy with him because of a mutual dedication to life and perception; my severe Yankee background is enlivened by his Gallic enthusiasms and his creative optimisms.

Lartigue's remarkable photograph *Grand Prix of the Automobile Club of France, 1912*[1] thrilled me on first sight in the 1930s. The extraordinary energy of the fast-moving racing car, wheels distorted into spinning, leaning ovals and spectators sharply tilted in opposing angle, delighted and perplexed me. I finally determined that he was using a camera with a focal-plane shutter, which moved across the film from top to bottom (we now usually find such shutters moving from left to right, but the principle remains the same). Because the image is inverted in the camera, the exposure begins at its base; the shutter slit meets first with the lower rims of the wheels. If the shutter opening is narrow, the exposure for any part of the picture can be very short, yet the slit may move with moderate speed. Thus, as the slit moves across the film, the subject's lateral motion is progressively exposed as a forward-leaning image.[2] Lartigue "followed" the racing car as well; hence the stationary but apparently leaning spectators on the left. I was fairly sure of my analysis but approached Lartigue in Arles with the rather naive question, "Did you use a focal-plane shutter?" His eyes sparkled: "Ah, but yes! I intentionally did it that way!" This photograph remains one of the very few I have seen that interprets movement with such energy and vitality.

As for the portrait reproduced here: it

was made with a Hasselblad 500C and 120mm S-Planar lens on Ilford HP3 film, developed in Edwal FG7 and printed on Oriental Seagull Grade 2. As the camera was hand-held and the subject lively, all the negatives I made are not crisp. The cattle stockade was of darkly weathered wood; one of its corner posts had a thrusting noble shape which I used in several of my compositions. As often occurs — negatives beautiful, likenesses poor. A moved head, eyes closing or closed, a moment of a budding smile miscaught as a grimace — all photographers have these heartbreaking accidents to contend with. Three negatives out of many were satisfactory.

Only recently was I able to achieve a print that approached my visualization. I visualized this photograph in stronger, more Nordic values than the negative provided. The light of southern France was very strange to me; everything seemed more luminous than it appeared in the photographs. Lartigue's white hair literally gleamed in the drab surround, yet the configurations and textures of skin, wood, and earth proved quite depressing as revealed in my normal negative. I should have attended my meter readings and adjusted ex-

posure and development accordingly. But I was cautious and did not extend development into the "plus" level as my records indicated I should. I sometimes trust my intuitions over my meter, and not always with good results!

1. Book 1, Figure 6–6.

2. Book 1, Figure 6–5.

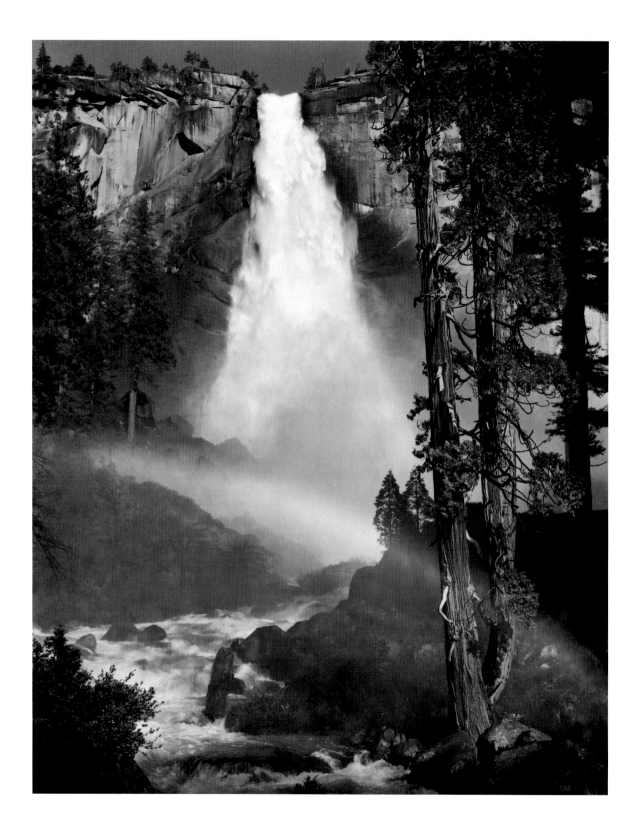

Nevada Fall

Yosemite National Park, c. 1947

One spring day I packed my 8×10 view camera, two lenses, filters, and six double film holders, three filled with black-and-white film and the other three with color film. All this, together with the heavy tripod and lunch, weighed quite a lot. I feared my equipment might be drenched in the heavy mist on the Mist Trail near Vernal Fall at this time of year, so I used the longer alternative, the horse trail, dry and hot in the noon glare. The object of this excursion was to photograph the rainbow in front of Nevada Fall, which was booming full at this time of year and produced rolling clouds of mist that swirled down the canyon for more than half a mile. I arrived hours before the sun was in position for the rainbow to appear, and I scouted out an ideal spot to set up the tripod. I could anticipate the approximate position of the rainbow by first noting where the shadow of my head might fall; the rainbow is about 44° from the axis of the sun.

It was apparent that I had several hours to wait, and I spent part of the time considering images produced by lenses of different focal length. Because of terrain and the complexity of the forest I was limited to one nearly ideal spot for my set-up. I had the time to engage in a protracted ballet with the tripod — forward, sideways, backward, and raising and lowering. All showed important changes in the relation of the branches of the nearby trees to the waterfall and the cliffs. I had a particularly hard time with the small tree in the extreme upper left corner of the image. There were many tips of branches to contend with that are not seen in the picture because of rigorous exclusion from the field of view. The tripod was set up in a jumble of rocks, and changing its position — even slightly — was arduous.

I missed on one small detail which ruffled; the right-hand tree of the two little cedars near the center of the image meets a branch from a nearby tree. I should have lowered the camera at least a foot to avoid this merger, but the front leg was already set at minimum length, and finding good footings for the other two — and for my own two as well — was a formidable task. In addition, the mist was blowing strenuously from the falls, and the camera had to be covered most of the time. The camera remained dry, but the focusing cloth and

the photographer were being soaked! The sound and fury of the waterfall, the clean air and driving mist were unforgettable.

With the stately passage of time the rainbow appeared above the river and slowly rose to the position seen in the picture. I feared to wait longer because the sun would be soon setting behind the ridge of Glacier Point. I made a color photograph first, before the afternoon light became too warm. The luminance scale of the subject was beyond the exposure scale of the color film. I had anticipated this and had pre-exposed two films at the studio (using a large neutral gray card as target and placing its luminance on Zone II½).[1] This worked very well; I placed the waterfall luminance on Zone VII and held the subtle high value, while retaining some value above black in the dark shadow areas because of the pre-exposure. I was making field tests of the very first Ektachrome film for Eastman Kodak Company. The Ektachrome positives have long since faded; Kodachrome was far more permanent, and I now wish that I had made duplicates on that film.

For the black-and-white exposures, I inserted the Wratten No. 8 (K2) filter behind the lens and figured the appropriate exposure to preserve some trace of substance in the shadowed tree trunks and yet hold some texture in the waterfall. The sun was directly behind the camera and the waterfall was extremely flat. The filter helped a little in separating the bluish shadows in the depth of the water mass, but the value differences shown were held by the placement of the water on Zone VI½ of the exposure scale and giving Normal-plus-one development[2] in Edwal FG7 to the Kodak Super-Panchro Press film.

These subtle high-value differences are not easy to hold in the print and are usually lost in the conventional engraving processes. Only with the laser-scanning reproduction process can such delicate high values be retained with certainty. The print demands strong blacks in the shadowed tree trunks and surrounding ground, and what faint textures the negative reveals in these areas are printed through; otherwise the dark areas would be weak and reduce the sense of brilliance of the white water.

Some urban aesthetes claim this photograph is just a bit of scenery and is certainly not art. May they and their opinions rest in peace! I think it is a choice bit of Chaos organized into some kind of expressive Order.

I do not desire to impose a definition of creativity on anyone.

Most photographers realize that in their art, above all other graphic arts, *subject* can both dominate and restrict if the essential elements of creative expression are not clearly applied. The function of abstract art is to free the qualities of form, line, value, and color from the usually imperative domination of subject. A photograph can never be as free of the entanglements of subject as can a painting, but the medium does permit a wide range of points-of-view and non-realistic values.

1. Book 2, pp. 119–123.

2. Book 2, Chapter 4.

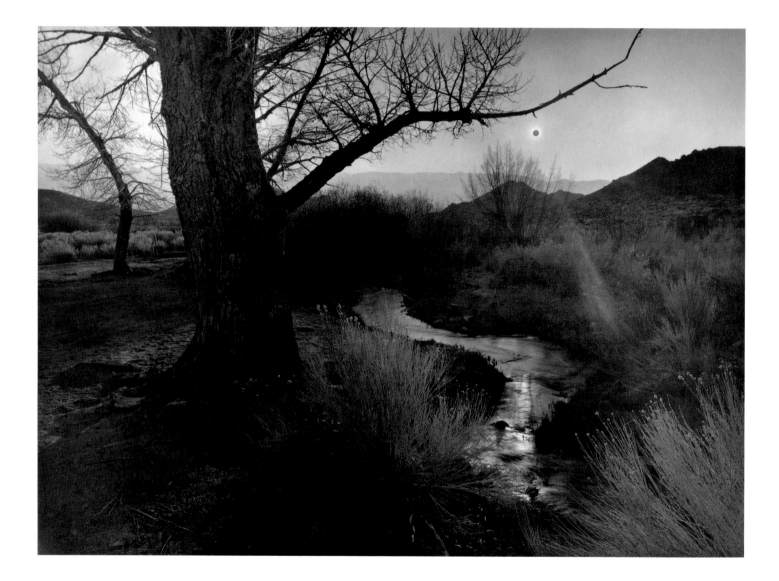

The Black Sun

Owens Valley, California, 1939

While I recommend concentration of spirit and mind on the image problem at hand, I confess that I have occasionally wandered into conjecture — possible experiments with a problem may flash into urgent need of completion as I am working my way into visualization of an exciting photograph. This happened as I was setting up my 5×7 Linhof with a 5-inch Ross Wide-Angle lens to make this photograph.

I first saw the image as containing a great flare around the sun, with the other areas of the photograph about as they appear in this reproduction. I then recalled the effect of reversal of a very bright image; the high negative densities actually *decrease* with very high exposure, far beyond the normal range, and produce a dark or black area in the print — called solarization.[1] With the thick-emulsion film I was using, this reversal could be revealed by use of a compensating developer, such as the Windisch Pyrocatechin formula.[2] Thus I visualized a black sun in the print, from an almost transparent reversed area in the negative caused by the extreme overexposure of the sun itself. It is interesting to note that the reflection of the sun on the stream is of nearly normal value.

My first negative was planned for development in Kodak D-23. The film was Kodak Super-XX, a fine material of the "thick emulsion" type. The sun flared strongly in the sky, and in the center of the flare was a small circle of *slightly* gray value, representing a partial reversal of the sun's image. The second exposure was identical to the first, but compensating development was planned for the desired reversal effect. It was gratifying to see both negatives as experiments and one, *The Black Sun*, as a striking surrealistic image. It was proof that the subject may prompt ideas, ideas crave visualizations, and craft makes their realization possible.

With this, as with most of my photographs, the subject appears as a found object, something discovered, not arranged by me. I usually have an immediate recognition of the potential image, and I have found that too much concern about matters such as conventional composition may take the edge off the first inclusive reaction. Recognition and visualization are often blended in a single moment of awareness. In this instance I recognized the potential for using an unconventional process and I visualized the outcome much as it

appears here — a black sun in an otherwise normal-looking scene. With practice the image is visualized in considerable detail before thought intrudes, and the exposure can be made as soon as the camera has been prepared. There is a certain inevitability in the creative process, at least through the making of the negative.

On some occasions the print seems as inevitable as the negative, but usually I find that it presents other problems, evoking direct control of values. The values are established in the original visualization but remain locked up in the densities of the negative until, by recollection and careful procedure, they are transcribed in the print to our aesthetic satisfaction. This particular photograph was intended to convey a feeling of light throughout; that is, I wanted to avoid areas of solid, empty black. Obviously, the brightest area in the print is that adjacent to the sun; next are the sun-reflections in the stream; and next, the sky itself. The trees and earth are fairly deep in value, but — very important — they are not black and empty. The implication in this photograph is that wherever there is significant shadow value there is light — otherwise we have nothingness.

My photograph was made before black holes and neutron stars were generally known. An astronomer once said to me, "You must be careful how you use that term, '*Black* Sun.'" I replied that it was primarily an emotional/aesthetic title. A title like "reversed sun" would be inane. Please note that this is definitely *not* an eclipse. I am sure some viewers consider the sun an artifact — some manipulation of the negative, or perhaps a small black disc pasted on the print! I assure everyone that it is a straight image of the sun (albeit reversed), an honest application of a well-known photographic effect.

1. Book 2, p. 87. It may be that modern thin-emulsion films will not respond so generously to the reversal effect (solarization) as the old thick-emulsion types, of which there are now very few.

2. Book 2, p. 234.

White House Ruin

Canyon de Chelly National Monument, 1942

In 1941 Secretary of the Interior Harold Ickes appointed me "Photo Muralist" for his Department. The project was to make photographs of the National Parks, Monuments, Indian lands, reclamation developments, and so on, under Interior's administration. I was to provide large images for the halls and meeting rooms of the Interior Department building, and potentially for the Department's offices throughout the country. We also discussed the possibility of installing photographs in all the National Park Visitors' Centers, to suggest to the public the scope and variety of the National Park System and encourage understanding of conservation. This project (the first trips in 1941 and 1942 were intended as preliminary surveys) was terminated by World War II and was never revived, although I continued doing related work with the assistance of two Guggenheim Fellowships (1946 and 1948).

One bright morning on a trip for this project, I was photographing in the Canyon de Chelly and came across a strangely familiar scene. I moved my 5×7-inch Zeiss Juwel camera to what seemed the most effective viewpoint and made two photographs of the old ruins nestled in the high streaked cliff on the north side of the canyon. One was taken with a 145mm (5½-inch) Zeiss Protar, a wide-angle lens when used with the 5×7 format, and the one shown here was made with a 7-inch Dagor lens, on Kodak Super-Panchro Press film.

Only when I had completed the print months later did I realize why the subject had a familiar aspect: I had seen the remarkable photograph made by Timothy O'Sullivan in 1873, in the album of his original prints that I once possessed. I had stood unaware in almost the same spot on the canyon floor, about the same month and day, and at nearly the same time of day that O'Sullivan must have made his exposure, almost exactly sixty-nine years earlier. (His title was *Ancient Ruins in the Canyon de Chelle, N.M.*) Obviously I had come across one of the most rewarding locations for a photograph of this remarkable relic, left by a tribe of Anasazi Indians who, apparently because of a continuing drought, were forced to abandon their homes and move elsewhere in the Southwest about A.D. 1200.

I visualized the image very much as it appears in the final print. My photograph is framed differently than O'Sullivan's. At

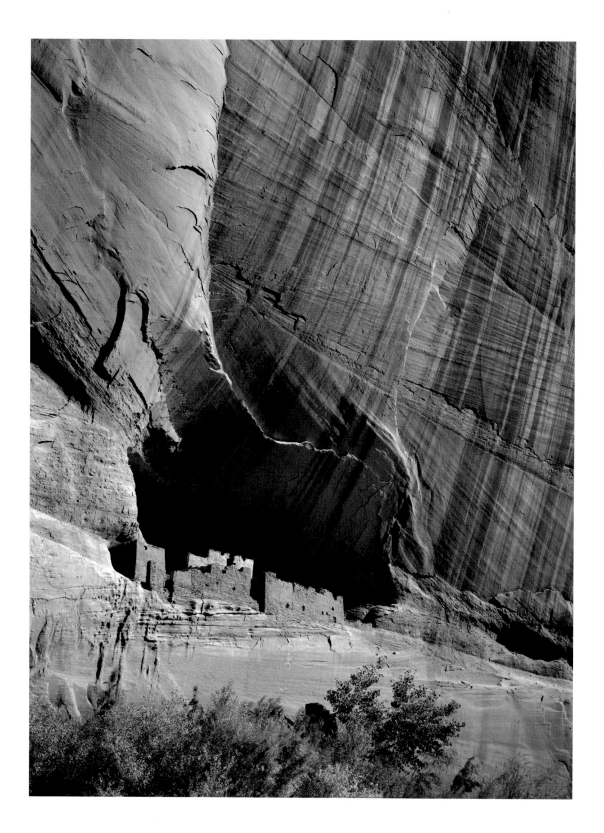

this time I had completed development of the Zone System and used it with understandable devotion in the field. I made an embarrassing number of miscalculations in those years and also suffered from faulty shutters, light-leaking film holders, and dust. How the great early photographers managed their arduous wet-plate process in Southwest heat and dust, and how the glass plates endured months of mule-back transport without breakage, have always been beyond my comprehension! Perseverance, toil, imagination, and good fortune are represented in the important photography of early Western place and time. I often recall how close my colleagues and I came to disaster in the field, even with modern equipment and communications.

Technically, my problem was primarily filtration. The cliffs are yellowish with dark vertical stripes (natural drainage) from above. The recess in which the ruin stands is shadowed and illuminated chiefly by reflected sky light, which is usually bluish. O'Sullivan, like all photographers of his time, was limited to blue-sensitive emulsions that did not record the red or green portions of the spectrum;[1] the interpretation of the subject values was restricted (sometimes enhanced!) thereby. In his photograph the cliff stripes and yellow-red areas were rendered quite dark, and the shadow area of the recess was full of light and detail because of the reflected bluish sky light. These early photographs often have a quality of luminosity in the shadows that is difficult to achieve with present-day panchromatic film (sensitive to all colors). For my photograph, orthochromatic film (not sensitive to red) would have been superior to panchromatic because of the greater detail it would have revealed in the shadow areas.

I knew that, with the low color saturation of the cliff rock, the panchromatic film would not adequately separate the yellows and light reds; a red filter would make things worse. A blue filter like the No. 47 would have given values very similar to those of the O'Sullivan photograph, but I had lost my blue filter. I used a green filter (Wratten No. 58), which better defined the sunlit areas; it also darkened the shadows in the recess. The green filter lowers the values of red and blue but lightens yellow and green values.[2]

While my print is vigorous and suggests the brilliancy and clarity of the scene, the

O'Sullivan photograph conveys more *luminosity*, enhanced by the warm color of the 1874 print. The combination of the wet-plate emulsions and albumen printing-out papers gave a greater exposure range, but the modern papers have greater density range and "brightness" effect.[3]

I first became aware of early American photographs when Francis Farquhar (businessman, historian, mountaineer, and a close friend from the 1920s) gave me an album of O'Sullivan's photographs of the Southwest. Published by the United States government in 1874, it was a collection of original prints mounted on light cardboard and efficiently bound. It was a pictorial report of scenes encountered by the Wheeler Survey Party of the United States Geological Surveys West of the 100th Meridian, led by First Lieutenant George Montague Wheeler. I gave this album to the Museum of Modern Art in memory of Albert Bender, and found another copy a year or so later at a price of $12.50! Several images in the album are magnificent by any standard, and others are simply good clear records. Their state of preservation varies; some look as fresh as I think they appeared when made, but others show fading and discoloration.

This is due perhaps to inadequate processing and the chemistry of the mount boards, as well as to the method of mounting the prints.

The early settlers of the West brought back to civilization tales and images of wonder from the vast domains beyond the Mississippi. The carefully conducted government surveys were as accurate as they could be at the time, but there were tall tales in descriptive literature and impossibly theatrical paintings, mostly by inferior artists, that sent hordes to visit or migrate to the wondrous lands. While extraordinary to the adventurous spirit, many of these lands were inhospitable and dangerous, yielding disaster as well as excitement, poverty more often than bonanza, to the men and women hardy enough to reach their geographic goals.

It is difficult for the modern urban American to conceive of the qualities of the open uninhabited lands of the West only 100 to 130 years ago. We forget that many tribes of American Indians have left records of their civilizations in the form of ruins, artifacts, and legends. The Anasazi left many relics of their habitations, such as those of the Canyon de Chelly and its tributary, the

Canyon del Muerto. These ancient peoples apparently suffered from extreme drought in their time — perhaps prophetic of the drought that again threatens the Southwest, accelerated by the consumption of the crowds of people overburdening the natural resources of the land.

I have thought about this land while traveling through it and observing its precarious status quo: beautiful, yet on the verge of disaster. I have also thought (with small factual knowledge) of the ancient years when the inhabitants — some warlike and some, like the Pueblos, relatively peaceful — were appropriate in number and demands to the resources of the earth. Betatakin, Mesa Verde, Chaco Canyon, and the numerous ruins of abandoned settlements tucked away in the canyons, caves, and cliffs throughout the arid lands, have an important message for our society, endangered by its arrogant exploitation.

Among O'Sullivan's photographs are some astonishing images, notably the *White House Ruin*, and *Inscription with Black Ruler*, both in the Canyon de Chelly. The latter is almost surrealistic in effect. These photographs grew in interest over the years for me, and I found myself looking about for other early American photographs. At that time the field was shallow; emphasis was on historical value only, and I found few pictures that interested me as photographs. Beaumont Newhall's extraordinary *History of Photography*[4] opened our eyes to the creative importance of many early photographers. The Daguerreotypists and calotypists, the wet-plate photographers — O'Sullivan, Jackson, Muybridge, Watkins, and others — were rediscovered and reevaluated in recent decades. No longer were their images viewed as merely musty historical records, fixed in dreary albums and frames; the best were recognized as glowing perceptions of the scenes, people, and the spirit of earlier days.

1. Book 2, pp. 21–25.

2. Book 2, pp. 99–100.

3. Book 3, pp. 41–42.

4. Museum of Modern Art, 1939; fifth, fully revised, edition published in 1982 by The Museum of Modern Art, distributed by New York Graphic Society Books.

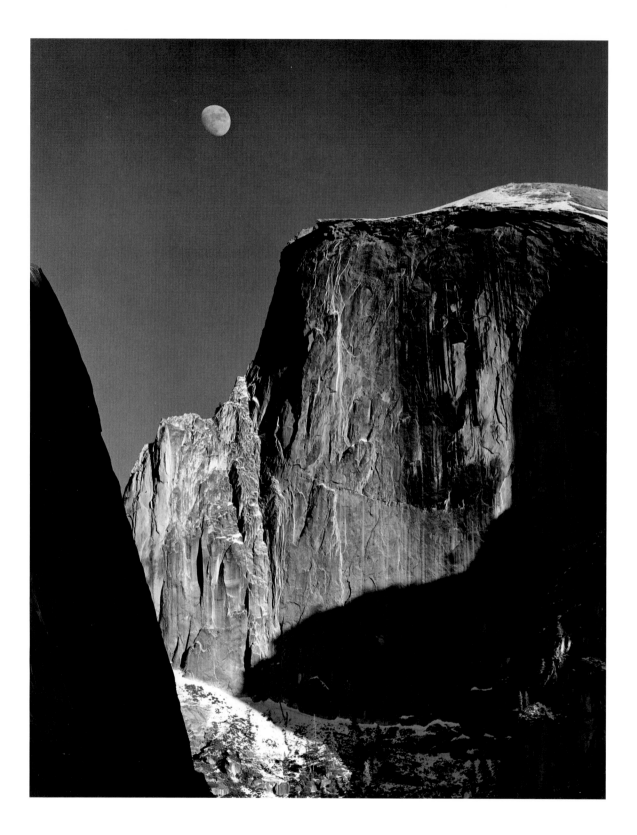

Moon and Half Dome

Yosemite National Park, California, 1960

I have always been moonstruck and have many moons in many pictures — but only one at a time! Practically all of my early moons were overexposed; some are just hopeless circles of white, and, if printed down, would be only discs of gray without texture. When I first received the S.E.I. Exposure Photometer, I found that its $\frac{1}{2}°$ field of view allowed me to measure closely the actual brightness of the moon; I determined that the luminance of the moon is approximately 250 c/ft^2, a value confirmed by the United States Naval Observatory.

With consideration for the average foreground or distant landscape values, the ideal placement of the moon on the exposure scale is usually Zone VII;[1] this holds logical textural value for late evening illumination on foreground or landscape areas. After dark the moon is, of course, the most brilliant object in view; it can be exposed on Zones IV to VIII and the details of its surface can be subdued or exaggerated as desired. At Zone VIII or higher, it will show little, if any, texture.

I happened to be driving toward the Ahwahnee Hotel in Yosemite Valley one winter afternoon about 3:30 and saw the moon rising to the left of Half Dome. The sky was clear and the late afternoon shadows were advancing on the 2000-foot cliff of the Dome. The picture shows the moon as gibbous, more than half full but not yet full. The luminance of the moon and sky together approached 400 c/ft^2 (the sky was about 150 c/ft^2);[2] we must remember that the moon is *behind* the sky, and the sky value *adds* to the very consistent luminance of the moon.

To separate the moon and the sky I used a strong orange filter,[3] a Zeiss optically flat filter made for the Zeiss Hasselblad lenses. This filter reduced the value of the sky, allowing the moon to shine with conviction. The filter also lowered the bluish light reflected into the mountain shadows by at least one zone (one lens stop). I placed the luminance of the moon on Zone VII; the effective shadow values fell between Zones II and III. As I recall, the exposure (with the 4x filter factor) was $\frac{1}{4}$ second at f/11 on Kodak Panatomic-X 120 film, at a film speed of ASA 32. The lens was a Zeiss Sonnar 250mm.

My Hasselblad camera was on a tripod, and to minimize vibration I released the mirror before operating the shutter. I made several exposures — two with the 150mm

Sonnar, but the wider angle of view was by no means as effective as that of the 250mm lens. I visualized the image in vertical format, the cropping closely determined from the start. As many do not realize, the moon moves surprisingly fast, and, with the magnification of the 250mm lens with a $2\frac{1}{4} \times 2\frac{1}{4}$ negative size, a fairly short exposure is required to overcome its motion.[4] The image size was roughly equivalent to that obtained with a 40-inch lens on 8×10-inch film.

I knew from the start that development would be Normal-plus-one.[5] The contrast was greatly strengthened (the sunlit cliffs registered 400 c/ft^2 and are suitably bright), and the shadow areas were slightly deepened in value in the printing process. I have made prints of this image from 8×10 to 30×40 inches; it holds value and definition well in large size.

At the time I was becoming fluent with the Hasselblad, and many of my best images since have been made with that most excellent camera. I am often asked if there are important differences in performance between good cameras of the same size. There are many excellent cameras available, and the photographer should select one

that performs well for him and that is well made throughout its system, of course within limits of cost and need. In addition, there is a "feel" about a particular camera; an emotional empathy seems to develop toward certain equipment. I sometimes sense that the camera itself may encourage the photographer to relate to particular subjects favorable to the camera's format and other characteristics. This is, of course, a subjective appreciation of the capabilities of the eye and the camera.

As soon as I saw the moon coming up by Half Dome I had visualized the image. It was then a matter of walking several hundred feet to the point that best revealed the scene clear of nearby trees. There is always the chance that the best visualized remote images cannot be achieved; the optimum viewpoint may be physically inaccessible and the view cluttered with unexpected and unmanageable foliage, etc. I have had many such disappointments, taxing both patience and ego! One photographer, around 1870, trimmed all but the top branches of a fir tree so that a clear view of Yosemite Valley could be obtained from the old Wawona Road. The effect was horrible, both in the photograph and in the

landscape! I might remove a dead twig or a beer can from the field of view, but the original scene (excepting the beer can!) should be preserved for future observers.

I have photographed Half Dome innumerable times, but it is never the *same* Half Dome, never the same light or the same mood. I am told by mountaineers that the three most distinctive mountain shapes in the world are the Mustagh Tower in the Karakorams, the Matterhorn in the Alps, and Half Dome in Yosemite National Park. Half Dome is a great mountain with endless variations of lighting and sky situations and seasonal characteristics; the many images I have made reflect my varied creative responses to this remarkable granite monolith.

1. Book 2, pp. 61–62.

2. Book 2, p. 12.

3. Book 2, pp. 103–106.

4. Book 1, pp. 116–118.

5. Book 2, pp. 71–79.

Church and Road

Bodega, California, c. 1953

Simple Georgian architecture emigrated with people from England centuries ago and spread throughout America, undergoing logical adjustments related to the rigors or affluence of various regions of the country. In primitive areas the structures were simplified to essentials of frame, siding, and ornamentation. In regions of wealth they echoed the sturdy buildings of Britain, as represented, for example, in the churches of Boston and Charleston, South Carolina.

Throughout history architectural modes have evolved: Romanesque Catholic basilicas, Hebrew Byzantine domes, and from Spanish Mexico came such Baroque magnificences as Mission San Xavier del Bac (see page 108). Protestant affluence is represented in the conspicuous examples of St. John the Divine in New York City and the concrete clone of Gothic style represented by the Episcopal cathedral in San Francisco. My old friend, the architect Nathaniel Owings, feels that the purest example of the Gothic spirit in America is the Church of St. Thomas by Bertram, Grosvenor, and Goodhue, on Fifth Avenue in New York. I am also aware of some marvelous modern edifices of devotion such as the new Coventry Cathedral in England, the Corbusier chapel at Ronchamp, France, the little Saarinen chapel at the Massachusetts Institute of Technology, and the Maybeck Christian Science Church (1911) in Berkeley, California. The basic adobe style of desert environments was preserved in the many primitive chapels of northern New Mexico, the essence of simplicity and beauty (such as the Saint Francis Church, Ranchos de Taos; see page 90). I am not a churchgoer, but I admire the temples of belief when it is obvious they represent depth of devotion and integrity of style. Above all, I believe it is essential that those who photograph architecture should know something about its qualities.

California has a number of simple churches of the Georgian style in the coastal and Sierra foothill areas. They have a plain, stark beauty which, to me, is vastly superior to the contemporary shopping-center-style horrors in which I think God might feel embarrassed. The Bodega church expresses aesthetic qualities that I believe have been captured in this photograph. The image reflects my original visualization, although I have not been pleased with some prints I have made. An object as simple

and chaste as this church is demands the utmost simplicity of composition and isolation from distracting surround-intrusions. Steve Crouch of Carmel made a magnificent photograph of this church at a different time of year and day; from the projecting entrance wall the low sun reflects on the facade as a beautiful glow of light, a unique and rewarding effect.

I saw the image as a rather narrow composition; some bothersome things such as rocks, stumps, and posts had to be cropped out, and the "lift" of the church and its steeple is intensified by the narrow format. I could not find a satisfactory distance (at ground level) to show the full facade of the church and to suggest the upward sweep of the road. As I moved away from the church the road lost its integrity and was interrupted by a larger crossroad at its base. Distant structures appeared over the hilltop, and the sense of scale and depth was lost.

I then moved my car to the base of the little road and set up my camera on the platform. This gave a fine perspective of the road, and at the highest elevation of the tripod the doorstep of the church was just visible. My 4×5 view camera did not have a rising-falling back adjustment; in order to include the full expanse of the road I tilted the camera down. This, of course, distorted the church, as I was using a 5-inch Ross Wide-Angle lens. I then tilted the camera-back into vertical position and used adjustments of both the rising and tilting front.[1] Because the lens axis was off-center and the steeple was close to its limit of coverage, the inevitable geometric effect[2] slightly elongated the vertical proportions, enhancing the soaring quality of the structure.

I used a Wratten No. 12 (minus-blue) filter with Kodak Plus-X film developed Normal-plus-one[3] in Edwal FG7. The sunlit church was very brilliant, and I felt that value should be placed on the exposure scale so as to be certain the delicate clapboard lines would show clearly. The white boards were placed on Zone VII and the deepest shadows fell on Zones II–II½, lowered by the filter. The exposure was $\frac{1}{10}$ second at f/22.

When I am in practice the operations described above are practically automatic; all aspects of procedure fall into place without conscious thought. The visualization was positive and clear, and all decisions seemed inevitable. Confident as one may be, it is still advisable to make final check to be

certain nothing has slipped with tripod, camera, or mental determinations. I have had disheartening failures because I overlooked some significant detail.

Printing this picture is not easy, because the mood is so important to hold. Clearly the white church should dominate, yet it must not be harsh or lacking in texture. If the shadow on the building were lighter, the foreground values would also be lighter and the strength of the image would suffer. When the print is wet, the lines of the clapboards are barely visible; when dry they appear clearly. If they look well in the wet print they will usually be depressed and gray when dry because of the dry-down effect.[4] This problem required quite a few proofing and drying trials before I achieved a satisfactory print.

1. Book 1, Chapter 10.

2. Book 1, pp. 158–159.

3. Book 2, Chapter 4.

4. Book 3, pp. 82–84.

Merced River, Cliffs, Autumn
Yosemite National Park, 1939

This photograph was made in late autumn, on a chilly morning when the air was crystal clear and still and the silence impressive. There is often a mournful quality about fall in Yosemite: the Merced River is very low, and the waterfalls are gone for the year. Autumn color is never brilliant there, but the dark gold and russets of the oaks and willows have a particular quiet beauty. I came across this subject in the western area of Yosemite Valley, and was immediately arrested by the image that came into my mind.

The camera position was strictly limited; about fifty feet of a narrow sidewalk on the west side of the El Capitan Bridge was my playing field. With the 8×10 camera, the 10-inch Kodak Wide-Field Ektar lens was the only choice. A lens of shorter focal length would have included unwanted fragments of sky, which would have had to be cropped out of the image. A 12-inch lens would have severely crowded the tree and river. The 10-inch lens was perfect for the situation. I recall using a yellow Wratten No. 8 (K2) filter with Isopan film at ASA 64. Since most of the scene was in shade, its contrast range was low. I placed the average luminance on Zone V

and indicated Normal-plus-one developing time (in a tray, as usual).[1]

I had experienced my first visualization with *Monolith, The Face of Half Dome* (see page 2) in 1927. The concept of visualization became fully formed along with the planning of the Zone System about a decade later. In fact, it was clear to me by 1939 that the Zone System had little meaning without visualization; without, in other words, having an image goal in terms of particular values, which the careful application of the Zone System assured. In 1939 I was fairly adept in visualizing the basic values desired in the image, but I was only at the threshold of proficiency with the Zone System approach.

In retrospect, I believe I should have given this negative a little more exposure with the same Normal-plus-one development. The gray granite rock and the oak leaves are very close in value; the No. 8 filter did not help much in separating them. A red filter would have had but little effect on the foliage, since its basic color saturation was low, but it would have lowered somewhat the values of the cliff by further reducing the bluish illumination from the open north sky.[2]

During printing I dodged[3] the dark areas in the lower left section for not more than 10 percent of the total exposure time; again any obvious graying of the deep shadows would be very unpleasant. A few shafts of early sun touched the leaves and the grasses of the riverbanks. The latter required some burning-in, because the sunlit yellow grass was much the brightest element of the scene.

I have not yet made a print that fully satisfies me. The negative prints fairly well on Ilford Gallerie Grade 3, but while it is about as good a negative as I could have expected in terms of holding all values, I nevertheless find it very difficult to make an expressive print. Merely preserving the values results in a rather flat image, lacking in the mood and tonalities I visualized. It is a subject that might be better revealed by use of a warm-toned paper such as Agfa Portriga. With other negatives intransigent printing problems have been overcome by discovering the optimum paper, developer, and toning combination, and much depends upon the mood of the photographer.

A photograph like this is usually more effective in large size, because, at normal viewing distance, we are more aware of the contrast differences between small areas; the details are visually better separated and appreciated. A small print at normal viewing distance may appear flat and uninteresting. The print size should usually be considered in the original concept.

I find it interesting to consider how I would have visualized and made a color photograph of this scene. I can imagine a very quiet and luminous effect of subdued hues; the elements here that made a black-and-white image difficult would be most favorable to color photography. The low contrast of the subject would be compatible with color processes. My first problem would be to reduce the inevitable blue cast produced by light reflected from the open sky. We know this light is of high effective color temperature and, relative to sunlight, is recorded as an obvious blue on color film unless corrective filtration is used. Green foliage in shade takes on a cyan color from blue sky illumination, which I find very unpleasant. Autumn yellows and reds can be somewhat cooled by bluish light even though they may seem vivid to the eye. To say that this blue/cyan effect is *real* may be

true in the physical sense, but we must realize that the eye compensates for differences in color temperature to an astonishing degree. A normal eye does *not* see this high color-temperature effect, and I believe we should construct our color images based on our visual perception and our visualizations.

This, of course, is merely the first stage of visualizing color. Once we know the filtration required for normal results with the film used and color of the light, we can then apply additional filtration and use controls in color printing to make whatever adjustment or departure-from-reality we require, within the limitations of the processes. I have found that the Zone System is invaluable in color photography, primarily in relation to exposure, but of course its application poses very subtle considerations.

Few subjects lend themselves to *both* black-and-white and color image concepts. Years ago, at a Yosemite Workshop, Marie Cosindas agreed with me that she was seeing photographs as compositions in color; her camera visualizations were often inappropriate to black-and-white imagery. I believe this experience favorably influenced her great career in color photography. Such experiences, perhaps not fully understood at the time, may create or confirm controlling lifetime concepts and skills.

1. Book 2, Chapter 4.

2. Book 2, p. 136.

3. Book 3, pp. 102–110.

Edward Weston

Carmel Highlands, California, c. 1940

One day when visiting Edward and Charis at their Carmel Highlands home, I expressed the desire to photograph him. I did not see any situation around his home that satisfied me, so I asked Charis if she knew of an appropriate area for a photograph of Edward. Always imaginative, she suggested a very large eucalyptus tree nearby: "Lots of exciting roots in view." We drove to the tree, which was less than a thousand feet from the site of the Highlands home Virginia and I were to construct seventeen years later.

At first I was not satisfied with the location and I began to explore nearby. Edward sat down at the base of the tree to await my decision. A picket fence nearby offered a good possibility, and I walked back to the tree to get him. When a few yards from the tree I suddenly saw the inevitable image, a quick visualization of a very successful photograph. The relatively small figure at the base of the huge tree, the convoluted roots, and the beautiful quiet light — what more could I hope for?

I pleaded, "Edward, please just keep sitting there." I was very excited and fumbled my meter, dropped my focusing cloth and inadvertently kicked the tripod leg. Edward was amused and relaxed. I used the 10-inch Kodak Wide-Field Ektar on my 8×10. The eye perceived light in every area of the scene and the subject seemed soft; however, with the meter I found that the actual range, from the lowest value to the foggy sky light reflected from Edward's head, was greater than I first imagined. I placed the important low values on Zone III and the high value of the head fell between Zones VII and VIII; obviously a normal negative scale. I recall the exposure as $\frac{1}{2}$ second at f/32 with Isopan film (ASA 64), developed normally. It prints well on Oriental Seagull Grade 2 paper or Grade 3 Ilford Gallerie.

One may question the relatively high exposure of the head value.[1] The forehead is the highest reflective area of the head, much brighter with a high angle of light than other parts of the face. With a large image of a head these values would be placed lower (Zone VI) or Normal-minus development would be given the negative. With a smaller image, a head may fall higher on the exposure scale and retain logical value. Edward's head reads quite well in the general surround of values. It being a foggy day, the light was diffused and smooth over the entire subject.

Under a clear sunny sky, with random areas of sunlight and shade, the technical problem would have been severe and the visualization entirely different. To preserve the luminosity of the scene, I would probably have placed the shadows on Zones III and IV. The sunlit area would then have fallen quite high on the scale and Normal-minus or water-bath development[2] would have been required. This is, of course, conjecture, and experience leads me to believe I probably would not have reacted to this subject under high-contrast conditions.

I wonder what Edward was thinking during this session. A highly intuitive artist, he paid little attention to what he called "complexities." Through experience alone he had developed a personal equivalent of the Zone System. His vision, selection of subject, and his craft worked wonderfully together, and he was fortunate in working almost exclusively on "assignments from within." He deliberately put aside all considerations that did not directly or indirectly relate to his work. Some major artists have no patience with those who work in other fields or take other approaches to their own field, a "fundamentalist" attitude that merely indicates a closed mind.

Edward had strong opinions and concerns, but I found that he was quite tolerant of the diverse approaches of photography. He simply was not capable of or interested in technical discussions beyond his own methods and controls.

He was a bit concerned and troubled once when he was asked to make some color photographs for Eastman Kodak Company, at the request of George Waters, a devoted friend and supporter. It was not a matter of his creative vision; Edward would have been among the greatest of color photographers. But the problems of exposure with color confused him at first. He relied for his first exposures on his personal approach to the use of the exposure meter, usually doubling the indicated exposure as he always did with black-and-white film. As it happened, this approach was nearly ideal for the kind of film he was using, and his images were beautifully exposed. It is unfortunate that color separation negatives were not made to preserve these outstanding photographs.

For me, this image is not only a reminder of a great artist and a warm and sympathetic friend, but holds much of the magical moment which not too many photo-

graphs contain. It is not a pose but an arrest of a situation, all the more fortunate because of the large camera used. With the small hand camera such moments are more easily approached; on the other hand, it is more difficult to control the vagaries of composition and perfection of craft. Immediacy is one aspect of photography; contemplation another. In Edward's photographs of even his most static subjects I sense the immediacy of his perception and his highly developed aesthetic response.

1. Book 2, pp. 60 and 148–151.

2. Book 2, pp. 229–232.

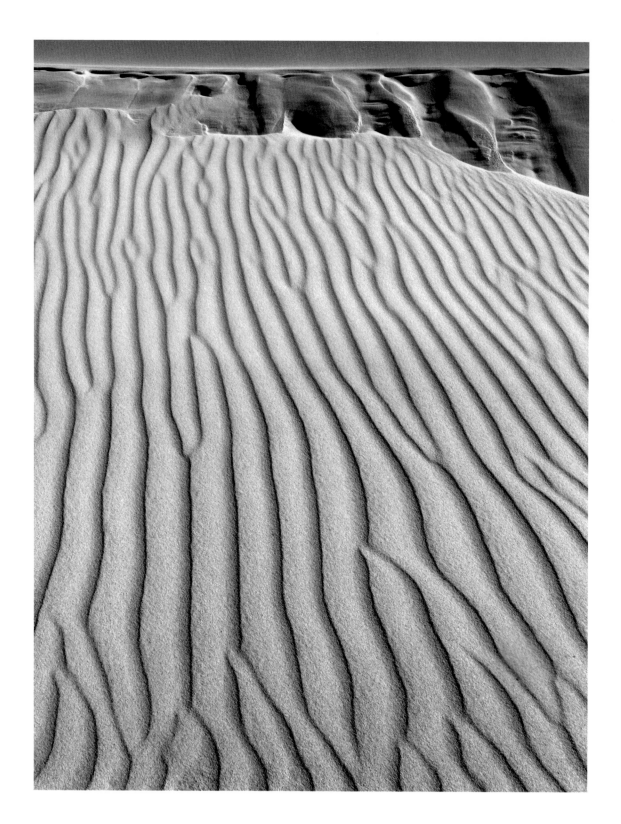

Sand Dune

Oceano, California, c. 1950

The Oceano Dunes are very beautiful, as the photographs of the area by Willard Van Dyke, Edward and Brett Weston, and many others attest. They are on the coast of California, southwest of San Luis Obispo and adjacent to the little village of Oceano (a one-time Theosophical center and a haven for creative and gentle people). I have visited the dunes many times, but only on a few occasions have wanted to photograph. The fogs, visually beautiful but not kind to sand textures and shapes as perceived by black-and-white film, dominate the summer months. In spring and fall the air is clear and the dunes are constantly modulated by the westerly winds from the Pacific. Unfortunately, of late some of this beautiful area has been taken over by the obtrusive dune-buggies that infest so many of the coastlines and dune lands of our country.

I have carried my 4×5 view camera over the entire area and have made some satisfactory photographs with it. I found, however, that my Hasselblad was more efficient than the larger camera for the subject, and with appropriate film and lenses I could make images of great clarity and depth of field. I used a tripod of moderate weight and have sometimes carried a three-point "folding star" of thin plywood, which prevents the tripod legs from sinking in the sand. This support can be folded into sections making a thin unit about 2½ feet long for knapsack carrying.

Part of the beauty of the dunes lies in the close ripples and textures of the sand, and the wide-angle 50mm Zeiss Distagon lens permitted me to secure definition in all areas adequate for 16×20-inch enlargements from the 2¼×2¼ negatives.[1] Of course, with a view camera the tilting back and front assemblies work wonders with near-far compositions by allowing control of the plane of focus,[2] but if returning to the dunes I would still prefer my Hasselblad with the 50mm or 40mm lenses. I seldom found a subject here that required a lens longer than 80mm or 120mm focal length with the 2¼×2¼ format.

The closest sand textures were about three or four feet from the lens and the distant dune crests about sixty feet away. With the 50mm Distagon lens, sixty feet is the practical equivalent of infinity. Using the depth-of-field scale on the lens, I set the focus at seven feet; the range of sharp focus was then about three and a half feet to

infinity. The accuracy of this hyperfocal-distance scale is attested by the fine definition in all areas of the negative. The exposure given was $\frac{1}{30}$ second at f/22 with a Zeiss yellow filter (factor 2x). With the camera on tripod, I released the mirror to minimize vibration during the shutter operation, and, of course, I used a flexible cable release.

I carefully shielded the lens, using my hat because the sunshade I had at the time was not as efficient as the one I now use. I observed carefully that the shadow of the hat did not extend more than midway between the lens flange and the aperature diaphragm edge; with wide-angle lenses the danger of vignetting by excessive shading is understandably greater than with normal and long-focus lenses.

Development of the negative was in Edwal FG7 for Normal-plus-one time. When I checked over my Exposure Record I found that I had made an error; I had stupidly used a film speed of ASA 64 for Panatomic film instead of ASA 32. I would have increased the development time to Normal-plus-two to help maintain appropriate densities for the middle and high values, but I did not realize what I had done until the negative was processed. For the print I

was obliged to use Brovira Grade 5; I now use Oriental Seagull Grade 4. The print is quite satisfactory, but some shadow areas demand subtle dodging to hold the desired values. I recount my error to remind photographers to make careful notes and to pay close attention to details like the ASA speed of the film in the camera!

It is important that fine-grain film be used for sharp optical rendition of the sand. The developer used should favor fine grain and high acutance.[3] At first I used Rodinal for such subjects, or pyro for large negatives. I used Edwal FG7 for years with considerable success, and I find Kodak HC-110 entirely satisfactory.

An interesting point to be made: film grain and grains of sand have much in common. I can ask for nothing better than a negative whose grain is smaller than the sharp optical image of the sand grains. However, if the image is not critically sharp, crisp negative grain can, to a certain extent, provide the illusion of actual sand texture. This implies use of a developer of high acutance — assuring that the grain is very sharp. Compare this situation with that of moving water and foam (see *Surf Sequence*, page 22); in such cases the foam may not be critically sharp, and incisive

larger grain may create the impression of crisp definition.

The sunlit dunes are full of light; it is unfortunately all too easy to get images of high contrast — Stygian shadows and blocked surfaces of sand. While I have been guilty of some over-strong images, I am usually careful to preserve the glowing impression of light and texture in dune negatives. Hence I would place my shadow values no lower than Zone III of the exposure scale.

With 35mm cameras, lenses as short as 18mm may be used for extreme depth-of-field effect. The images can be very spectacular, but they also can become tricky and commonplace. The near-far compositions of great depth and clarity often seem best suited to subjects that are not recognizably affected by obvious exaggeration and distortion of shape. The more obvious the possible effects are, the greater the demands on the perception and taste of the artist.

1. Book 1, pp. 48–52.

2. Book 1, pp. 148–154.

3. Book 2, pp. 182–185.

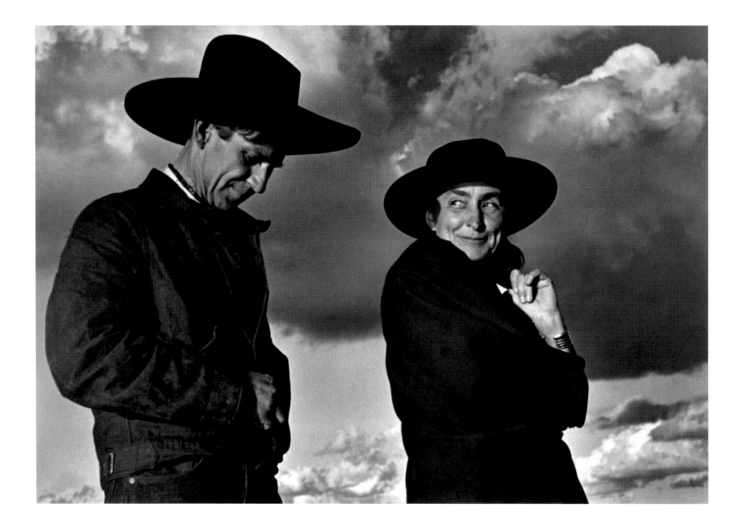

Georgia O'Keeffe and Orville Cox

Canyon de Chelly National Monument, 1937

My old friend David Hunter McAlpin is a genius at organizing excursions: everything is planned, and the plan followed, almost to the minute. I met him in New York in 1934 at a screening of a Russian film to which he had taken Georgia O'Keeffe, the great painter. He seemed a serious and devoted "snap-shooter" ("snapper," as O'Keeffe called him), but his interests in photography were far deeper than that. Stimulated by Alfred Stieglitz's circle and with direct contact with photographers such as Stieglitz, Eliot Porter, Paul Strand, and others, he became a most ardent supporter of the art. In 1940 he was the prime source of funds and organizational ability for the new Department of Photography at The Museum of Modern Art, New York, to my knowledge the first of importance in any museum. Dave (who was also a Trustee of the Museum), Beaumont Newhall, and I set up the Department; Dave became Chairman, I served as Vice-Chairman, and Beaumont was Curator. Dave has been a very important factor in the development of American photography.

I have been on several trips with Dave and friends — down the Intercoastal Waterway (from Newport, Virginia, to Savannah, Georgia), through New England, the High Sierra of Yosemite National Park, and, most memorable of all, to the Southwest on our first trip together. We gathered at the Ghost Ranch in the Chama Valley, about sixty miles northwest of Santa Fe, New Mexico. O'Keeffe was spending the summers there and soon acquired a handsome adobe house, which she retains to this day. She later built a very beautiful home and studio at Abiquiu, some miles to the east of the Ghost Ranch.

After several days in the Ghost Ranch area the trip began, a cavalcade of three cars with O'Keeffe, McAlpin, two friends, Orville Cox (the guide), and Adams. McAlpin had everything planned in great detail, and, with the exception of some delaying storms, all went like clockwork. We visited several pueblos, Mesa Verde National Park, and the Dolores River country and Ouray in Colorado. The high point of the journey was Canyon de Chelly National Monument in northeastern Arizona. It is an extraordinary area, and we witnessed a wonderful Southwest electrical storm that flooded Cosy McSparron's Trading Post at

Chinle, near the mouth of the canyon. We had explored the canyon before the storm and, when the heavy rain turned the canyon floor to quicksand, we took the four-wheel-drive route to points along the rugged south rim.

At one rim-edge I was walking around with my Zeiss Contax and I observed O'Keeffe and Orville Cox in breezy conversation standing on a rock slope above me. It was an inevitable picture. O'Keeffe and Cox were engaged in a bit of banter. The moment was *now*. If the camera was held level Cox's hat and O'Keeffe's figure would be cut into; a side tilt was necessary. Kneeling, I lowered the position of the camera, bringing more of the figures against the sky. This was intuitively and swiftly managed, and I made only one exposure.

I had used the 35mm cameras to considerable extent since the first Zeiss Contax (Contax 1) came on the market in the 1930s. I do not get along well with the automatic features of today's cameras, although I acknowledge that they have many advantages — superb lenses, electronic shutters, motor-drives, and ingenious accessories. But I want to have *complete* control of lens aperture and exposure; I prefer to use a spot meter such as the Pentax Digital Meter or the English S.E.I. Exposure Photometer, no matter what camera I am working with.

Prior to making this photograph I had planned exposure as best I could for the general situations, using my Weston meter. This was two or three years before I had worked out the Zone System. Through experience in the strong lighting of a bright Southwest day, I knew that I must give generous exposure for the shadows. I would take a meter reading of shadowed areas and give one-fourth or one-eighth the indicated exposure. In modern parlance this would place the shadows on Zone III or Zone II.[1] I would then read the high values and, if they fell high on the scale signifying a high-contrast subject, I would indicate less development time for that roll of film. Obviously, with the same roll of film I tried to work with the same luminance range for all exposures. For a roll containing varied subject scales, I found by experience that if I gave generous exposures (usually two times "average") with prime consideration for the shadows, and developed for two-

thirds the normal time, I obtained a high level of success. I would later correct the image contrast by printing on various contrast grades of paper. When one roll contained only subjects of normal or flat luminance range, I gave normal or more-than-normal development respectively.[2]

At that time I was using Sease No. 3, a paraphenylene-diamine developer formula, for 35mm negatives. In those days all professional films I used were of the thick-emulsion type, and grain was a problem. Certain developers worked better for 35mm negatives than the standard formulas used for large-format negatives. The tendency for the negatives to block-up in the high values was very apparent with the condenser enlargers in common use at the time. I recall the quality of the first semi-diffusion enlarger I possessed for small-format negatives; the 35mm negatives yielded, with this type of illumination, print quality somewhat comparable to what I obtained with my 4×5, 5×7, or 8×10 negatives in the diffused-light sources of my large-format enlarger,[3] or by contact printing. Since most of the 35mm film of the time was of the thick emulsion type, light passing through the edges and corners of the negative was less sharp than the central areas, especially when relatively short focal-length enlarging lenses were used. The grain in these outer areas was obviously "mushy." The use of long-focus enlarging lenses could overcome this problem. A similar edge-corner effect was observed in negatives made with short-focus lenses, usually where the densities were fairly high.

I developed the roll in Yosemite a few weeks after the picture was taken. While drying, the roll slipped out of the clothespin on the drying wire, fell to the floor, and was stepped on! The only frame out of the thirty-six that was damaged was this one, by far the best of the roll. When I have a subject that I feel is unusual I try always to make a duplicate exposure simply because there might be an accident like this one or a defect in the image area. But if the subject is fleeting, like the facial expressions in this image, there is no way to make duplicates. I do not like to "bracket" exposures except when I have not been able to measure the subject luminances or if I doubt the accuracy of the shutter. Bracketing is

the refuge of the unknowing, a trial-and-error procedure that is wasteful of film and weakens the sense of disciplined procedure. However, if I have forgotten or misplaced the record of the ASA film speed, or if I am not confident of my meter, shutter, etc., I *must* bracket through various exposures above and below the estimated normal time.

I find that if I carefully observe the various precisions that the Zone System offers and have a positive visualization of the desired image, my results are almost always satisfactory, technically, at least. However, a simple arithmetic error — omitting, for example, lens-extension or filter factor — can be serious. Remember that the exposure record of each photograph, which should include the particulars of exposure as well as the development instructions, serves as a diagnostic reference in case of a perplexing failure.

I have done considerable work with the 35mm and hope to continue in the future. I stress the importance of choosing (if possible) the ideal camera and format for the problem at hand. In general, I favor a tripod-mounted view camera for static subjects that invite contemplation — or a small hand-held camera for "the decisive moment." This term is the title of Henri Cartier-Bresson's superb book on his work; it defines better than any other description I know the importance of highly trained awareness of the "moment" and the immediate and intuitive response of the photographer. It should be obvious to all that photographers whose images possess character and quality have attained them only by continued practice and total dedication to the medium.

It is impossible to explain or comprehend the miracle of the eye and mind in such feats as anticipating a "decisive moment." We are concerned not only with a single aspect of the image, but with the complexity of the entire experience, a matter of the moment but also involving the realities of light, environment, and the fluid progress of perception from first glance to release of the shutter.

This photograph recalls for me the brilliant afternoon light and the gentle wind rising from the canyon below. I remember that we watched a group of Navajos riding their horses westward along the wash edge, and we could occasionally hear their singing and the echoes from the opposite cliffs.

The cedar and pinyon forests along the plateau rim were gnarled and stunted and fragrant in the sun. The Southwest is O'Keeffe's land; no one else has extracted from it such style and color, or has revealed the essential forms so beautifully as she has in her paintings. Unfortunately the region invites "postcard pictorial" exaggerations of form and color, and emphasis on the picturesque.

1. Book 1, pp. 166–167.

2. Book 2, pp. 61–66.

3. Book 2, pp. 71–83.

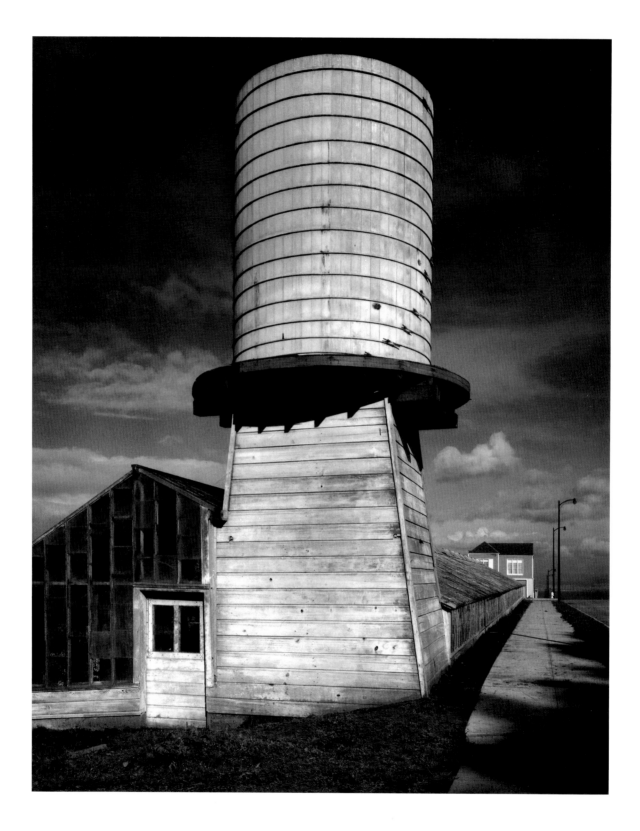

Old Water Tower

San Francisco, California, 1961

This water tower, a relic of the turn of the century, had a particular architectural quality. Definitely functional, it presented a certain nobility of form, and the slightly weather-worn painted surfaces had an intriguing textured quality.

I have always been pleased with this photograph. It represents an early 4×5 Type 55 P/N Polaroid Land film, a product I had been using in the field as a consultant for Polaroid Corporation. While I am sure other photographers were interested in the production of this positive-negative material, I am happy to say that I think my enthusiasm helped in its development. To have a print and a negative from the same exposure is a tremendous assist in the creative process.

It also taught me much of human nature. I found that there were photographers who disliked the process for two reasons: it was unconventional and therefore suspect, and it was a new concept and process, therefore too difficult to master. I found that there is surprising lack of interest in new ideas, especially those that demand some participation. "You press the button and we do the rest" is a tragic slogan, destructive of the concept of controlled craft and the functions of imagination.

Dr. Edwin Land and I had many discussions on this (for me) perplexing situation. He believed strongly that if a stable, simple, and high-quality photographic process could be universally available at reasonable cost, creative expression and communication would be enhanced at a scale heretofore considered impossible. I urged that the process be brought to the professional and creative photographers as well. I could see endless practical and imaginative potentials and pressed strongly for them. I am sure Land had thoroughly anticipated me. Being an enormously intelligent person, he well knew the realistic problems of research and development, manufacture and merchandising, and was understandably cautious.

This photograph presents an interesting optical situation. I used a 121mm Schneider Super Angulon lens, with the camera level on the tripod. I wanted to take full advantage of the great covering power of this lens. I raised the camera front to maximum, and then turned the camera up and tilted the lens and film planes to vertical. The top of the tank was very close to the edge of the optical field. Looking at the photograph, it is difficult to believe that the diameters of the tank's top and bottom are

identical. The tank's height is extended by the geometric realities of optics, and there is a distinct looming effect exaggerating the curvature of the metal supports toward the top.[1] Not only did the lens used permit great coverage, but my camera position also enhanced the perspective and scale differences in the image.[2] This is a good example of a departure from reality in image management. The eye did not perceive the definite looming effect which obtains in the image, and the photograph thus does not represent the visual, but a photographic, "reality."

I made the first exposure for the print, then adjusted the exposure as required for the negative, from which the print reproduced here was made. In printing, the principal problem is to retain texture in the painted surface while preserving the impression of brilliance and the quality of light.

The effective ASA speed for the Type 55 P/N print was about 80; for this negative it was about ASA 20. These speeds were based on my practical trials; each new batch should be tested.[3] So far, it appears impossible to achieve equal speeds for both negative and print. We can, however, work

directly for the negative, using the overexposed print as a proof for composition, image sharpness, etc. Due to the inherent nature of the silver-transfer process, Polaroid materials also have shorter exposure scales than conventional film; their scales are often similar to positive color film. Therefore, it is worthwhile to know both the effective speed and exposure scale of the particular batch of film used.

The immediate feedback of the Polaroid Land process is, I believe, very valuable in creative work. It does not in any way violate the visualization approach. It does give additional opportunity for refining composition and seeing small confusing elements of the subject that might have been overlooked in the original visualization.

Some photographers do not understand the value of Polaroid Land materials for serious work, and use them only as tests for conventional black-and-white or color films. This is one logical routine use of the material, but I suggest that the positive-negative system be thought of as an important variation of the basic photographic process. I have had some extraordinary results with the various Polaroid Land films; some have matched in image quality many

of my best prints from conventional nega-
tives. Type 52 prints have a certain image
quality other materials cannot attain, even
though exposure and processing controls
are more restricted than with conventional
negative material.

1. Book 1, pp. 158–159.

2. Book 1, pp. 97–98.

3. *Polaroid Land Photography,* Appendix A.

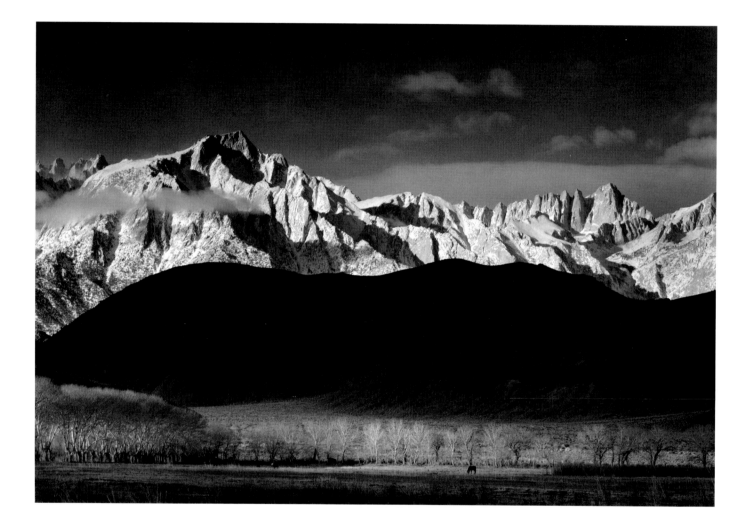

Winter Sunrise

Sierra Nevada, from Lone Pine, California, 1944

The eastern face of the Sierra Nevada is a 300-mile wall of crags and rugged gorges culminating in Mount Whitney, 14,444 feet above sea level and about 11,000 feet above the little town of Lone Pine. The Owens Valley region extends from Mono Lake in the north to Olancha and Owens Lake in the south, an arid basin between the Sierra and the White Mountains and Inyo Range. Beyond to the east lie the desert regions of California and Nevada, including Death Valley. It is a land of desolate beauty. Mary Austin wrote *The Land of Little Rain*, an American classic about this area, in 1904. Little did she then realize the disaster that was to come upon it in not too many years.

At the turn of the century it was a charming rural community, rich with farms, orchards, cattle, mines. It had all the water required for agricultural and mining purposes. Towns grew in the desert: Bishop, Independence, Lone Pine, Keeler, and others now mostly disintegrated and forgotten. Bishop remains in relatively healthy condition, but Independence, to the south, sleeps in weary old age. Farther south, Lone Pine is now in its final days. Remaining homes and rural properties have recently been bought up by Los Angeles, and it soon may join the ranks of the California ghost towns. Mono Lake promises to evaporate into a salt flat, although environmentalists are making noble efforts to preserve it.

The streams of the Sierra were copious in season from the melting snows, and water was no problem to the early settlers. Stands of cottonwoods decorated the lush farms, which were bordered by tracts of desert. A narrow-gauge railroad threaded along the eastern borders of the valley under the barren escarpments of the Inyo Mountains.

Then, in the early 1900s, the expanding urbanlith of Los Angeles sought water and reached more than three hundred miles north to possess it. By fair means and foul the water rights of farmers and cattlemen were bought out. The glistening bounty of streams flowing from the Sierra was channeled into aqueducts and tunnels to the thirsty southland, and the Owens Valley died a parched and dismal death. Now practically all the water of the area flows to the homes and swimming pools of the City of Angels, and an American tragedy is here for all who care to see.

Manzanar, the site of one of the World

War II relocation camps, is about fifteen miles north of Lone Pine. While I was photographing in and around the camp in 1943 and 1944 I made some of my best images (see page 66). I knew the region well; it is roughly 150 miles from Yosemite over the Tioga Pass — or 400 road miles southward when the Tioga is closed by snow.

The Mount Whitney group is spectacular in sunrise as seen from Lone Pine, and especially impressive in winter, when the snowy high peaks rise above the bare and dark Alabama Hills. (These hills were named by Confederate sympathizers during the Civil War for the battleship *Alabama,* in retaliation for the Northerners' naming Kearsage Pass in the High Sierra for one of their ships.)

While at Manzanar for a fortnight in the winter of 1944, Virginia and I arose very early in the mornings and drove to Lone Pine with hopes of a sunrise photograph of the Sierra. After four days of frustration when the mountains were blanketed with heavy cloud, I finally encountered a bright, glistening sunrise with light clouds streaming from the southeast and casting swift-moving shadows on the meadow and the dark rolling hills.

I set up my camera on my car platform at what I felt was the best location, overlooking a pasture. It was very cold — perhaps near zero — and I waited, shivering, for a shaft of sunlight to flow over the distant trees. A horse grazing in the frosty pasture stood facing away from me with exasperating, stolid persistence. I made several exposures of moments of light and shadow, but the horse was uncooperative, resembling a distant stump. I observed the final shaft of light approaching. At the last moment the horse turned to show its profile, and I made the exposure. Within a minute the entire area was flooded with sunlight and the natural chiaroscuro was gone.

I used my 8×10 Ansco view camera with the 23-inch component of my Cooke Series XV lens with a Wratten No. 15 (G) filter. The film was Isopan, developed in Kodak D-23. The negative is rather complex to print. It is a problem of agreeable balance between the brilliant snow on the peaks and the dark shadowed hills.

The enterprising youth of the Lone Pine High School had climbed the rocky slopes of the Alabama Hills and whitewashed a huge white L P for the world to see. It is a hideous and insulting scar on one of the

great vistas of our land, and shows in every photograph made of the area. I ruthlessly removed what I could of the L P from the negative (in the left-hand hill), and have always spotted out any remaining trace in the print. I have been criticized by some for doing this, but I am not enough of a purist to perpetuate the scar and thereby destroy — for me, at least — the extraordinary beauty and perfection of the scene.

I have often thought what a privilege it would be to live and work in this environment, perhaps best before the turn of the century when the efforts of man brought more beauty to the land than now, with our pavements, wires, contrails, and desolation. This photograph suggests a more agreeable past and may remind us that, with a revived dignity and reverence for the earth, more of the world might look like this again.

Graffiti, Abandoned Military Installation

Golden Gate Recreational Area, California, 1982

This, one of my most recent photographs, may appear quite different from my usual and expected work. I have made a considerable number of photographs of subject matter other than the natural scene. I do not have different basic attitudes toward various subjects; if I am excited by a possible image — be it natural or related to the works of man — I respond with creative enthusiasm.

This particular image was made during an excursion with my good friend Jim Alinder through the beautiful Marin Headlands just north of San Francisco. We were on one of those pleasant photographic trips that do not come about as often as they should. Companionship in the field can be helpful and stimulating to creative work, but if the personal levels of appreciation and the creative tempos are unequal it can be difficult to observe and visualize. While we have a somewhat different approach to photography, Jim and I share creative excitement. We first visited some of the old haunts of my youth. I found it a bit sad to be restricted to the road, as I could recall the wild free days of hiking the hills and climbing the tawny cliffs above the Golden Gate, sixty years ago.

The old army gun emplacements of World War One or earlier vintage are still there, the massive walls and platforms weathering into the tired gray of old concrete and rusty metal. Some contemporary primitive had left his or her mark with daubs and constructions in paint that had taken on a patina and a wistful quasi-antiquity that commanded my searching eye. It seems that almost anything that endures in time acquires some qualities of the natural. Bleak shapes grow into a kind of magic that, once seen, cannot easily be ignored.

I immediately noted a few potential subjects, and the visualizations followed with enthusiasm. In an inclusive photograph the entire wall would appear as a hodgepodge of shapes and values, but it was possible to isolate some exciting sections. I recognized at least eight possibilities and photographed four. I believe that the one reproduced here is the best.

I used my Hasselblad 2000 with the 250mm Zeiss Sonnar lens; this gave a good perspective and revealed more of the deeply recessed inner wall than would a lens of shorter focal length. I wanted to render the white circular shape with brilliance yet enhance what little texture it contained. Actually, it was a light-gray value against a middle-gray wall. These two values could

easily be controlled in themselves, but the shadowed areas were about one-sixth the luminance of the sunlit wall and presented a value-control problem. The shapes in the shadowed areas were important in terms of the total composition and required strengthening in contrast beyond their measured values.

I placed the higher shadow value on Zone III½ and the sunlit white shape fell on Zone VII½.[1] I would have preferred it on Zone VII, but I feared the shadows would have lost required density had I reduced the exposure. I gave the Ilford FP4 roll film Normal-plus-one development[2] in Kodak HC-110 (diluted 1:7).

People have said to me, "Why don't you just *make* the picture and forget all that technical gobbledygook?" Practice will bring facility to any serious photographer. Because of ample practice in the field, the technical considerations were decided in about three seconds.

Making the print was much more difficult than determining the negative exposure. The visualized values for both sunlit and shadowed areas required luminous local contrast for the shadows and a bright but textured value for the sunlit shape. The

basic information was in the negative but required considerable enhancement in the print. I might have enhanced the shadow values by further increasing the development time, but this would have increased the density of the sunlit area and called for the use of a lower-contrast paper with attendant loss of brilliance. Local contrast in both areas would have suffered — not in the informational but in the aesthetic sense, relating to my original visualization. It is possible to visualize images that are on the edge of, or beyond, the capabilities of the process. These limitations should be recognized when the subject luminances are evaluated.

I first made a very soft proof to confirm what the negative contained. It was obvious that the sunlit shape was rather low in texture. A print on Grade 2 paper helped it little. I then tried Oriental Seagull Grade 3 and got a full range of values and information, but the feeling of light and texture was not satisfying. I went on to Seagull Grade 4 but found that with Dektol the image was of too high contrast; it was impossible to hold desired values in both sunlit and shadowed areas. I then prepared the developer as follows: 500 cc Kodak Selectol-

Soft, 1000 cc of water, and 100 cc Kodak Dektol.[3] The print exposure was made to favor the high values, and some dodging of the shadowed areas with a rectangular card was required. Increasing the proportion of Dektol to 200 cc gave a more satisfying tonal range.

We must always bear in mind that the image reproduced in ink cannot be the same as the original silver image, and should be considered an end in itself. Retaining and perfecting the original concept in the reproduction is an important objective. In making prints for printing-press reproduction, I have usually been obliged to adjust their reflection-density range to about 1.50 to match the limited scale of the engraver's negative.[4] Otherwise, either the high or the low values of the print suffered; retaining the desired values of one was at the expense of the other. The laser-scanning process allows images of fine-print quality (having maximum tonal range) to be reproduced with high fidelity to the photographer's intention. The image scale can be enhanced, revealing qualities of value and acutance actually beyond the ability of the photographer to produce on photographic paper. Such, of course, should be

under the direction of the photographer, since unpleasant exaggerations can be made by well-meaning but unimaginative technicians. One restriction with laser scanning at this time is that the print to be scanned cannot be mounted, as it must be attached to a drum, which rotates during scanning.

How does the eye-mind mechanism perceive, recognize, and project the intuitive visualization, in black-and-white or color, on the creative consciousness? There have been assertions that this photograph may suggest certain schools of painting. It is true that I have seen a considerable amount of contemporary art, but I do not consciously associate these shapes on the gray wall with the purely imaginative forms in nonobjective painting. I was observing such shapes in the world about me long before I was aware of most contemporary art. I object to photographs that intentionally reflect appearances of other forms of graphic art, and I do not understand the purpose of paintings that painstakingly imitate photographs. To my mind both imitations are never as successful as original expressions. I feel that there must be a paucity of imaginative resources behind these imitative

efforts. However, *someone* produced these shapes that I photographed, and the artist might have been influenced by contacts with art. On the other hand there is the possibility that these are purely individualistic statements, with only coincidental reference to existing art forms.

Whoever made the graffiti remains unknown. The shapes have a certain ingenuity; they are not merely accidental. However, for me they are found objects, and I photographed them as such. Sometime, somehow, some person brought paint to this remote area and created a freely circular shape, and with some broad strokes added smaller shapes around it. For what purpose, for what expressive pleasure or intent was this effort made? Such questions may remain forever unanswered.

All art, including photography, cannot be defined or explained because it relates to experiences not measurable in material terms. Physical procedures and techniques may be thoroughly discussed, but these are of little value unless a compelling creative reason-for-being exists. To borrow again from the statement by Alfred Stieglitz, the camera enables us to express what we have seen and felt in the worlds of nature and humanity.

1. Book 2, p. 57.

2. Book 2, pp. 71–79.

3. Book 3, pp. 93–95.

4. Book 3, pp. 182–188.

Glossary

Glossary

ADJUSTMENTS (of a view camera). The planes of the film and of the lens (i.e., the lensboard) may be tilted or shifted in relation to each other. This provides control over the subject areas that are focused on the film, and over the shape of the image projected onto the film. The basic adjustments are known as: rising and falling front and/or back; sliding front/back; swinging front/back; tilting front/back. The tripod top, to which the camera is attached, permits tilting the entire camera up and down as well as rotating it in any horizontal direction.

APERTURE. The diameter of a lens's opening, almost always adjustable, and measured in f-stops, which express the lens opening as a fraction of the focal length. Thus a lens at f/4 has an aperture that is one-fourth its focal length, no matter what the focal length may be. A change of one stop doubles or halves the light reaching the film (or paper, in enlarging), and thus is equivalent to doubling or halving the exposure time.

BLOCK-UP. Said of high values (light areas in print) when overexposure and/or overdevelopment cause a loss of separation so that subtle textures are lost.

BRACKETING. A procedure for making exposures at several different exposure settings, just to be sure some of them are right. Often a sign of inadequate knowledge of craft.

BURN-IN. A procedure during enlarging that allows additional exposure to be given to areas that otherwise will be too light in the print. Often a card with a hole cut in it is used to block out all but the light needed for the local area during the burning exposure. Burning-in time is always in addition to the basic exposure (see *dodge*).

CANDLES-PER-SQUARE-FOOT. The luminance (brightness) of a surface can be measured in candles-per-square-foot (c/ft^2), and these units are used in the Exposure Formula to determine the camera exposure settings via the Zone System.

c/ft^2. See CANDLES-PER-SQUARE-FOOT.

CONTACT PRINT. A print made by placing a negative directly on a sheet of photographic paper and projecting light through the negative. The resulting print is the same size as the negative, hence the need for enlarging with small-format negatives. Large-format negatives — 4×5, 8×10 and larger — are sometimes still contact-printed, but these too are often enlarged.

CONVERGENCE. Parallel lines in a subject may not appear parallel in the image, but may converge instead. For example, a rectangular subject such as the wall of a building will be imaged as a rectangle only if the film plane is parallel with the building. Thus, rather than pointing a camera upward to include the top of a building, the camera is set up with the three planes (building wall, lensboard, and film) parallel, and the lens is raised without tilting by use of the camera adjustment known as the rising front. This keeps

the film plane parallel with the building, maintaining geometric accuracy, while the lensboard is also parallel, ensuring that the entire facade can be focused sharply on the film. If the rising front is insufficient, and if the lens coverage is adequate, the camera may be pointed upward, the back tilted to vertical position, and the lens tilted to re-establish focus. Also, if necessary, the lens can be further tilted (or swung) to adjust focus for near-far planes of the subject without changing the "geometry" of the image.

CONVERTIBLE LENS. Especially in earlier years, view camera lenses often could provide more than one focal length, depending on whether the entire lens was used or one component removed. A *symmetrical* lens has two components of identical focal length. A *triple-convertible* lens also has two components, each of a different focal length, and both different from the combined effective focal length.

COVERAGE. The size of the circular image projected by a lens. The rectangular area of the film must be located within this image circle. When adjustments are used with a view camera, the lens's coverage — the size of the image circle — becomes important, since the image circle can be shifted in such a way that the image no longer covers the entire film image area.

DENSITY. The amount of silver deposited on a film or paper to form the image. High-density areas in the print appear black and represent dark areas of the subject. Low-density print areas are the light values, where light is re-

flected freely from the paper base. With negatives, a high density corresponds to a *light* subject value, and low density to a *dark* area. Density is measured in logarithmic numbers.

DEPTH OF FIELD. The range of distances in a subject that is sharply imaged. With a lens focused at a certain point, the depth of field means that areas somewhat in front of and somewhat behind the focus point will also appear acceptably sharp. The depth of field increases as smaller f-stops are used.

DODGE. The opposite of burn-in. During enlarging, light is withheld from selected areas of the print that otherwise will appear too dark. The procedure is to cast a shadow from a disk or other shape attached to a wire handle and held (with constant motion) between the lens and the paper during part of the exposure. Dodging time is always within the basic exposure time.

ENLARGING. The making of a print larger than its negative by projecting the image onto photographic paper.

EXPOSURE FORMULA. A formula that establishes the relationship between subject luminance and camera exposure. According to the formula, the correct exposure to record a given area as a middle value (Zone V exposure) is the reciprocal of its luminance (in c/ft^2) representing the shutter speed in fractions of a second, at an aperture number equal to the square root of the film speed. For example, with a film speed of ASA 64, f/8 would be the aperture; a luminance of 30

c/ft^2 placed on Zone V represents 1/30-second exposure time.

FILM SPEED. A rating of how sensitive to light a film is. The ASA speed rating (published by the American National Standards Institute, ANSI, successor to the American Standards Association) provides that a doubling of the film speed index number represents a doubling of the sensitivity, and this corresponds to a one-stop change in exposure. The European DIN speed rating has numbers that express the geometric relationship in arithmetic sequence, relating to a log increment of 0.10, as follows:

ASA	64	DIN	19	f/8	log	0.10
	80		20	f/9		0.20
	100		21	f/10		0.30
	125		22	f/11		0.40

FILTER. Optical glass or gel filters containing colored dyes are often used in black-and-white photography to modify the image values. A red filter, for example, withholds blue and green light, so that blue or green subject areas, like the sky or foliage, become darker than they would otherwise be. Kodak filters are identified with a Wratten number that has become a standard designation.

FILTER FACTOR. Because a filter reduces the amount of light reaching the film, a factor is usually applied to correct the exposure. The normal exposure *time* (i.e., the shutter speed) can be multiplied directly by the factor to give a corrected exposure time, or the aperture can be changed by an equivalent amount.

FOCAL LENGTH. The distance "behind" a lens at which it brings to focus light from a distant subject. Used as a measure of image size, since, all other things being equal (such as distance to subject and film format), doubling the focal length doubles the size of the image of any subject. Lenses commonly referred to as "telephoto" have long effective focal lengths, and produce large images of any subject, thus making distant objects appear closer. Lenses referred to as "wide angle" have shorter than normal focal lengths and encompass a broad subject area.

FOCUS SHIFT. The undesirable property of some lenses of shifting their focus when they are stopped down, thus requiring that focus be checked at the aperture to be used for exposure.

F-STOP. See APERTURE.

GRAIN. The clumps of metallic silver that make up photographic images, whether negatives or prints. Some films have more visible graininess than others, and this property can also be influenced by the processing of the film and the degree of enlargement.

GROUP F/64. An informal association founded in response to the prevailing Pictorialist school of the early twentieth century. The members of Group f/64, which included, Edward Weston, Imogen Cunningham, Willard Van Dyke, myself and others, declared themselves in favor of sharply focused images that exploited to the fullest the characteristics of photographic images, rather than attempting to make

photographs look like paintings or other graphic media.

IMAGE MANAGEMENT. My term for the controls used by the photographer to affect the point of view and the optical image projected on the film, as distinct from the controls of exposure and processing affecting the image values, which I formulated into the Zone System. Image management includes choice of camera and lens, positioning of the camera, control of depth-of-field and subject motion, use of camera adjustments, etc.

INTENSIFICATION. A corrective procedure for increasing the density of a negative (or print) chemically, usually to make up for inadequate exposure and/or development.

LUMINANCE. The measure of a subject's "brightness," usually expressed in candles-per-square-foot (c/ft^2).

NORMAL DEVELOPMENT, NORMAL-MINUS DEVELOPMENT, NORMAL-PLUS DEVELOPMENT, etc. These are Zone System labels for development procedures that yield negatives of normal, less-than-normal, and more-than-normal contrast, respectively. The Zone System allows the amount of contrast change to be quantified, so the change can be related to an exposure increase or decrease for a specific value of one or more *zones*.

ORTHOCHROMATIC. Refers to film that is sensitive to blue and green light, but not red. Many of my early photographs were made on orthochromatic glass plates or film, which gave a lighter value for blue sky than does panchromatic film, and often produced a very luminous rendering of green foliage in shade.

PANCHROMATIC. Refers to film that is sensitive to all colors, the standard today.

PAPER GRADE. A rating of photographic papers that indicates their contrast, from low contrast at Grade 0 or 1, to the highest contrast papers at Grade 5 or 6. Paper contrast grades are not consistent among the various brands.

PICTORIALISM. An approach to photography often characterized by sentimentality and soft-focus romanticism. Surfaces, textures and values frequently imitated the qualities of other media, and compositions were often derived from the conventions of painting.

PLACE-FALL RELATIONSHIP. These are Zone System terms that refer to the exposure scale of a subject. Once one luminance of a subject has been read and *placed* somewhere on the scale of zones, all other luminances *fall* on the scale accordingly.

POLARIZER. A device (similar to a filter) placed before the lens which causes light passing through to become polarized, that is, aligned in orientation. The polarizer is often useful in removing glare and reflections from water, glass, etc., when used at an angle of about 56° to the norm.

POLAROID TYPE 55 P/N. One of the 4×5 Polaroid black-and-white films, this one yields both a print and a negative. Several of my well-known images are printed from negatives made with this material (see *El Capitan, Winter Sunrise, Yosemite*; *Old Water Tower, San Francisco*, and *Mission San Xavier del Bac, Tucson, Arizona*).

PRE-EXPOSURE. A method of controlling contrast by giving a slight first exposure to a uniform value, followed by exposure of the subject. With Polaroid films, where contrast control in development is very limited, this is often a useful method. It is also sometimes used in printing.

RECIPROCITY EFFECT. The loss of effective film speed when a negative receives exposure for longer than about one second. A correction factor is usually applied.

RISING FRONT. See ADJUSTMENTS; CONVERGENCE.

SELENIUM TONER. A chemical often used in processing prints that produces a cooling of the image coloring and slightly increases density and contrast. Selenium toner also has archival benefit, and I use it for all prints. It is also an excellent intensifier of negatives.

SHUTTER. A mechanical device that controls the exposure time. A *leaf shutter* operates within the lens, and a *focal plane shutter* is located at the film plane and moves across the image area.

SPOT METER. A light meter that reads a very small area of the subject, determined by viewing through an optical system. Spot meters today usually read a 1° area from the camera position, thus making very precise measurement and exposure control possible.

VISUALIZATION. The process of "seeing" the final print while viewing the subject. With practice the photographer can anticipate the various influences of each stage of photographic procedure, and incorporate these intuitively in visualizing a finished image.

WATER-BATH DEVELOPMENT. A procedure that involves allowing developer solution to soak into the negative, followed by a period in a plain water bath. During the water-bath time, the developer continues to act in low-density areas, while it quickly becomes exhausted in high-density areas. The result is that the low-density areas receive, in effect, proportionally more development than high-density areas, reducing the overall contrast and enhancing shadow detail. With modern thin-emulsion films this compensating effect can be obtained by using two-solution formulas or by using certain developers at high dilution.

ZONE SYSTEM. A framework for understanding exposure and development, and visualizing their effect in advance. Areas of different luminance in the subject are each related to exposure *zones*, and these in turn to approximate *values* of gray in the final print. Thus careful exposure and development procedures permit the photographer to control the negative densities and corresponding print values that will represent specific subject areas, in accordance with the visualized final image.

Designed by David Ford

Production coordinated by Nan Jernigan

Type set by DEKR Corporation

Paper is Lustro Offset Enamel Gloss

Engraved and printed by Gardner Lithograph

Bound by Horowitz/Rae